DRAWING &
PAINTING PEOPLE

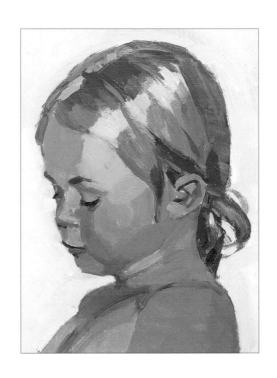

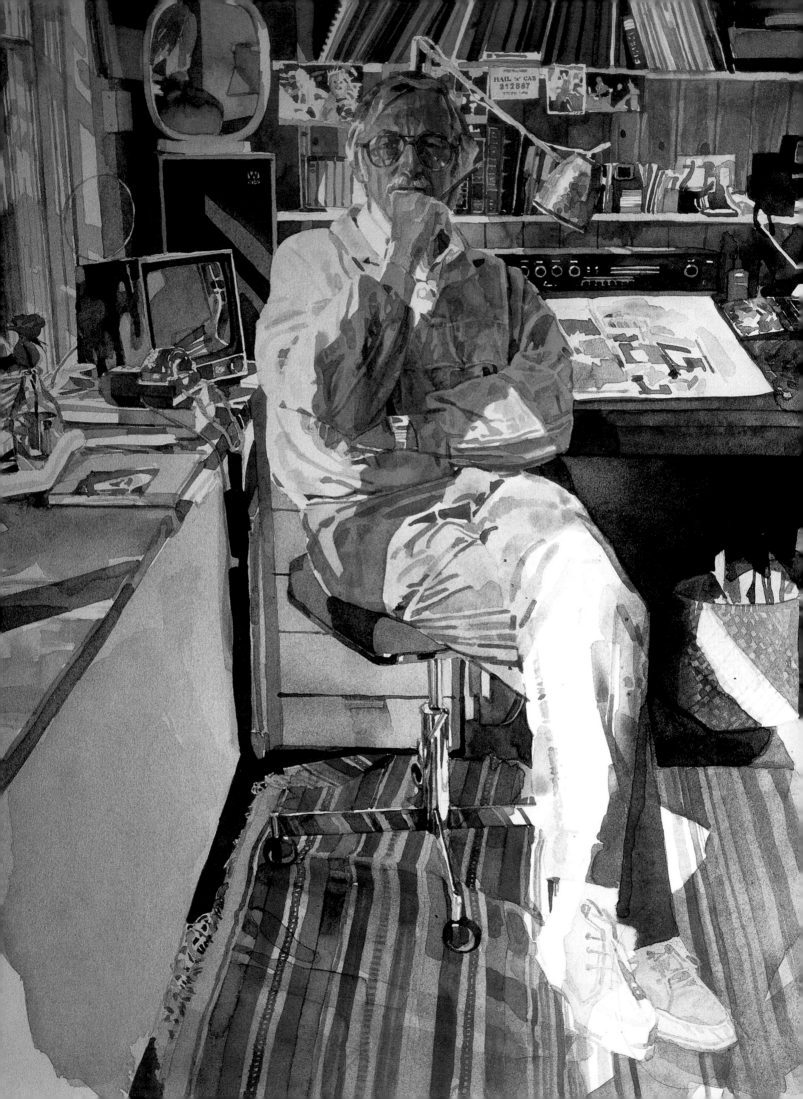

DRAWING & PAINTING PEOPLE

An easy-to-follow guide to successful portraits

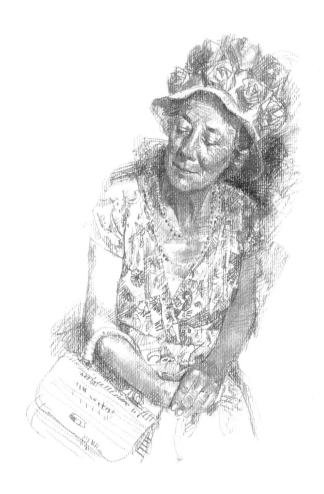

JOHN RAYNES

COLLINS & BROWN

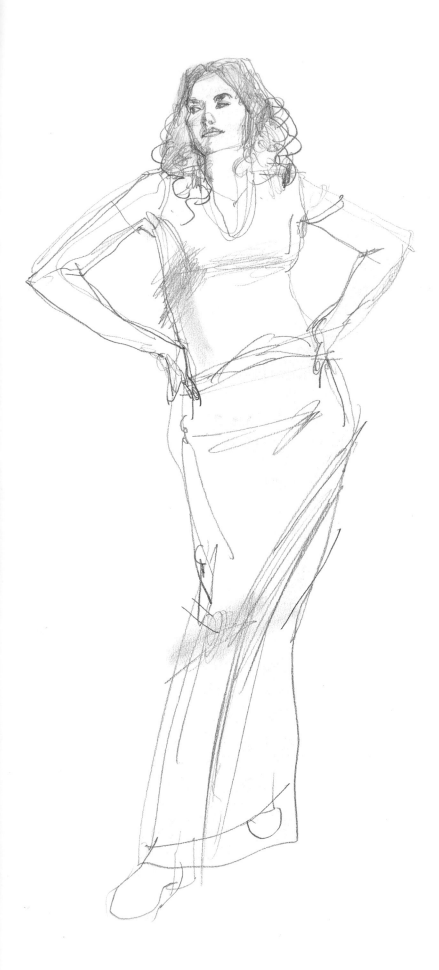

First published in Great Britain in 2000 by
Collins & Brown Limited
The Chrysalis Building
Bramley Road
London W10 6SP

An imprint of **Chrysalis** Books Group plc

3 5 7 9 8 6 4

British Library Cataloguing-in-Publication
Data: A catalogue record for this book is
available from the British Library.

ISBN 1 85585 762 6 (hardback)
ISBN 1 85585 785 5 (paperback)

Conceived, edited and designed by
Collins & Brown Limited

EDITORIAL DIRECTOR: Sarah Hoggett
EDITORS: Katie Hardwicke and Ian Kearey
DESIGNER: Claire Graham
PHOTOGRAPHY: George Taylor

Reproduction by HK Graphic and Printing
Printed and bound by
Kyodo Printing Co Pte Ltd, Singapore

Contents

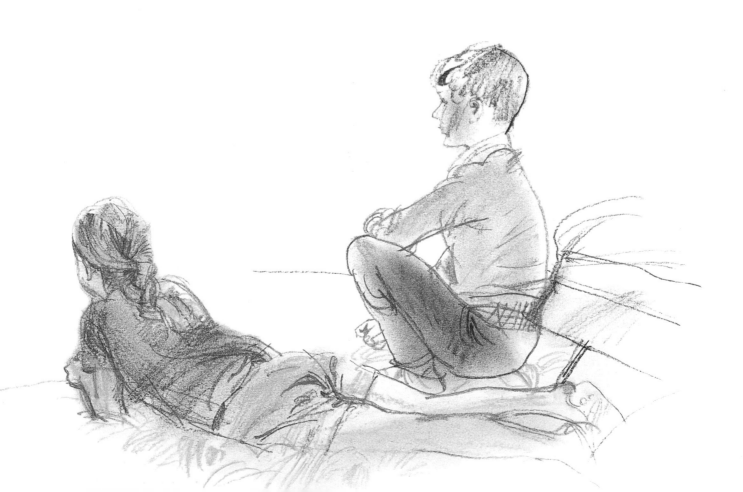

Introduction

Of all the subjects available to the artist, the human figure surely offers the most variety and creative choices. From close studies of a face to groups of people in a large setting, successfully depicting ourselves always repays any amount of learning and practice.

ACHIEVING A RECOGNIZABLE and convincing human likeness in a drawing or painting is often assumed not to be very easy; as one of Dickens's characters remarks, 'There are only two kinds of portrait – the serious and the smirk'. What makes a human likeness is a subtle and elusive quality that does not consist solely of a combination of the right hair and skin colour, shape of nose, mouth, eyes, and so on – important though these undoubtedly are.

The aim of this book is to help you to observe what makes a likeness, and to establish guidelines and offer suggestions and advice so that you can depict people with confidence. The book uses all the popular media to explain and demonstrate different practices and methods.

Before looking at ways of capturing people, it is worth taking a moment to explore how we observe others. In normal social intercourse the facial features, especially the eyes and the mouth, tend to be the focus of our attention. We pick up clues and cues from observing these features, all of which help us to understand how the other person is reacting and reinforcing or denying what we may be hearing. Although our conscious attention is riveted on these areas, at a deeper level we are storing less obvious information. It is this that enables us to pick out a familiar face instantly and without difficulty from a thousand others.

The obvious question follows: what provides the information needed for recognition? It can only be the abstract pattern that is unique to that particular

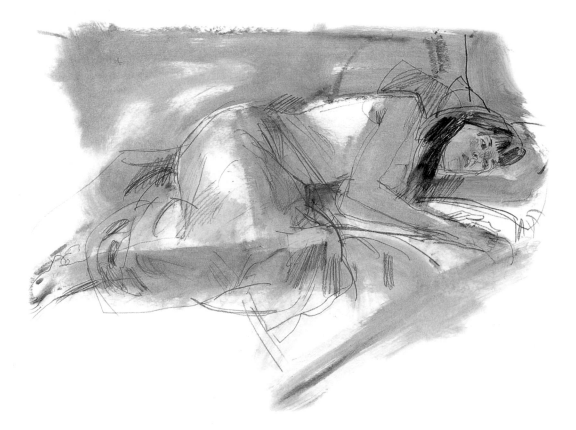

The whole figure
LEFT: *We may not think of the body's poses as being as immediately recognizable as facial expressions, but the combination of both in full-length work – reclining, sitting or standing – adds to our identification of the person being portayed.*

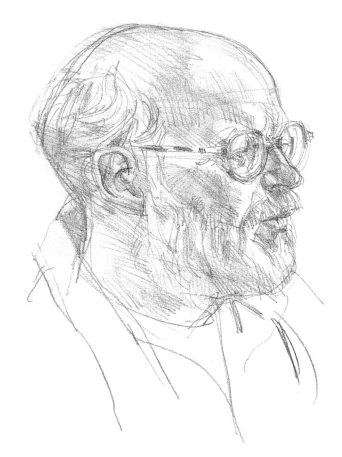

Exploring contrasts

ABOVE: *Making drawings of a bald or shaven head
enables you to observe the many different shapes of the
cranium, while facial hair obscures the musculature
and bone structure beneath it.*

face. There must be a map of the familiar face
stored somewhere in our visual memory which we
can superimpose on a blurred or oversimplified
image, and confirm that the smudges that represent
the eyes and nose and mouth are in the positions
that tell us that we are looking at one unique
individual – and none other. This is where likeness
resides – in an abstract pattern – and you must,
therefore, pay as much attention to the spaces
between the features as to the features themselves.

Learning the basics

To draw or paint a portrait that has a good likeness
to the sitter, the artist must, first and foremost,
identify and recreate this abstract pattern. Even if
the individual features that seem so important are
drawn marvellously accurately, a good likeness will
always be missed if they are not positioned in the

right places. The spaces between them must be
observed, and the abstract pattern must be right.

The key to seeing any pattern is, of course, to look
for it. Whenever you have the chance to observe a
face without causing offence, look between the
features. Try to see the form of the cheekbones and
the angle of the jaw. Check the distance of the
mouth line from the eye line. Imagine the shape
that could enclose the grouping of the features and
assess its size relative to the whole head.

The early exercises in this book show you ways
of assessing this characteristic pattern of shapes
by various measuring methods and by reference to
the anatomy of the head. The bony structure of the
skull is the dominant factor in the proportion and
form of a human head and face. The first part of
the book looks at this in some detail, and we will
also examine the musculature of the face,
in particular the muscles of expression, and those
of the neck, which support the head and are active
in moving it.

Once you have acquired an understanding of the
overall structure, you can move in and look at the
detail. Each single facial feature is a fascinating
structure in its own right, and you will find a close
study of these facial details very rewarding.

Towards abstraction

ABOVE: *The abstract patterns that make up any face are most
obvious in the early stages of a drawing or painting, but you
should keep searching for them throughout the work.*

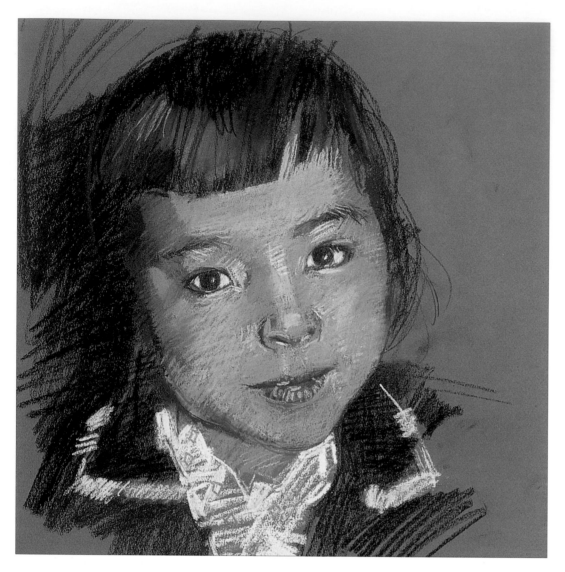

Capturing skin and hair colours

LEFT: *If there is one area where making assumptions just will not do, it is when putting down skin colour accurately. Whatever the ethnic group of your sitter, observe the variations in warm and cool skin colours and set down what you see – the combinations may seem unlikely, but close observation will pay dividends in the end.*

Colour

As you become more confident in rendering form and solidity, colour can be studied in more depth, and the book goes on to explain colour mixing and make suggestions for palette layouts. As with any object made visible by light, the human head may receive light from a variety of sources and will absorb and reflect it to produce a rich array of colours and tones. The colour of flesh encompasses many more hues than the pale pinkish yellow often sold as 'flesh colour' or 'flesh pink'. To paint all the human skin tones up to and including deep black, you will need a full range of colours.

Expanding your repertoire

However well you are able to depict the overall shape, proportions and details of a head, this will mean nothing if you are not able to bring your subject to life. Although capturing character and the vast range of human expressions is sometimes regarded as an arcane mystery, it can be solved by observation and practice. In addition to the many great works by master artists over the centuries, photographs, television and video have expanded the range of opportunities for the artist to study people, and these aids are examined and explored.

Further challenges are offered by full-figure portraits, whether standing, sitting or reclining. In these poses, a knowledge of some basic figure anatomy will help you to understand posture and balance, and the concealing effect of clothing, fabrics and patterns repays investigation.

All of this work and learning must be put into context, and choosing the appropriate format for your painting or drawing is vital for it to succeed –

as is the choice of background and the many kinds of light source and effect, from natural light to theatrical and artificial lighting. How you compose a picture, and where you place one or more figures within it, is simply a matter of understanding both a few 'rules' and the ways in which these can be broken for creative effect. You also have the option of incorporating objects and scenes that are part of people's lives and help to define their individuality and character.

Exercises, sketches and sitters

The exercises in this book are built upon step-by-step demonstrations that suggest ways in which you might handle a variety of subjects and situations. You must always remember, though, that no situation can be exactly duplicated, and you would be unwise to treat the demonstration stages as instruction in a painting-by-numbers exercise. Use each project as a sequence of working suggestions and trust your own judgement – your confidence will grow, and all will be well.

In this vein, it is always worth remembering that observing and making drawings regularly, and in every available situation, is one of the keys to success. The importance of practice and sketching cannot be overestimated, and this book offers tips and advice on how to make the most of the opportunities around you.

When it comes to finding an amenable and patient sitter, the most available, of course, is yourself. Most artists have drawn and painted self-portraits, and although you may think that you know your own face very well, you will be surprised at how much you discover if you look and draw with genuine curiosity.

Materials

Beginners often feel and express concern about what materials are appropriate for a particular subject. The truth is that there is no need to buy a lot of special materials for drawing and painting people. Probably it is best to use charcoal, pencils and the like for your early explorations of the structure of head and face, as these can be easily adjusted, but you should not feel restricted by this –

ballpoint pens, felt-tip pens, whatever comes to hand can be put to use. Throughout this book the uses of various media and what you can expect of them are described and demonstrated, but you should experiment freely and choose whatever you feel happy with.

The main thing, as in all drawing and painting, is to find a medium and a method that allow you to make radical changes to your drawing throughout its progress – the first exploratory marks are very unlikely to be right and your materials must give you the freedom to search out the form and likeness in an evolving drawing.

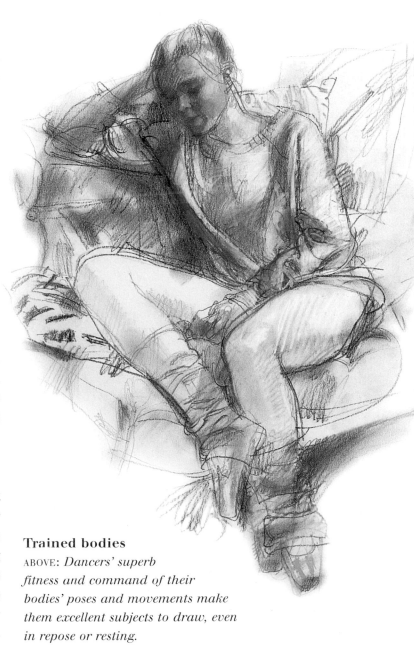

Trained bodies

ABOVE: *Dancers' superb fitness and command of their bodies' poses and movements make them excellent subjects to draw, even in repose or resting.*

The Face and Head

Making an accurate likeness of the head and facial features means that artists need to think about anatomical accuracy, proportions and dimensions, details and overviews – and much more – all at once! The truth of the matter, however, is that learning to observe as well as to look, and studying the individual components of the face and head, are mainly a matter of practice and common sense.

Shape and structure

The greater part of the head is a solid and immobile form, whatever the features may be doing. The secret of success in portraying the shape and structure of the head is to search out and render it with the same objectivity that you bring to the painting of any other form.

IT IS ALL TOO EASY TO become preoccupied by the details of a face and thereby to lose the overall shape and volume of the head on which they sit. Before tackling a drawing using a sitter, first try rendering some simple ovoid forms with as much solidity as you can. An ordinary hen's egg will do very well – a human skull fits quite neatly within this shape.

Because there is comparatively little soft tissue covering the human skull, the fundamental form of each individual head is almost completely dependent on this underlying bone structure. Even the facial area, where most of the mobile muscles are situated, tends to be dominated by the shapes of the brow ridge, the cheekbones and the jawbone.

Drawing from the skull, or an accurate model of one, is wonderfully instructive. Once you have 'learned' the forms of the skull you will look at live faces with a much deeper and more complete understanding.

The basic shape of the skull

From many viewpoints the complete human skull fits quite neatly into the form of an egg. Here, the left-hand shape is a drawing of an ordinary hen's egg, using tone to describe the smooth ovoid form – a useful exercise. In the middle drawing there is a suggestion of eye sockets, cheekbones and lower jaw, but the shape is still ovoid. Even when the cheekbone and jaw are shaped, the more detailed skull on the right still approximates closely to the previous ovoid forms. This is not an inviolable rule – it does not always apply to a front view, for instance – but looking for all-enclosing forms like this helps you to achieve solidity.

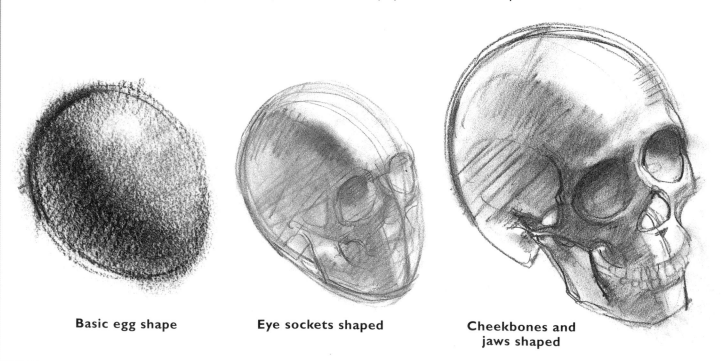

Basic egg shape **Eye sockets shaped** **Cheekbones and jaws shaped**

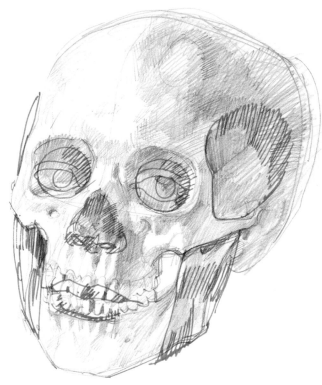

Filling out the skull

LEFT: *The orange parts of this drawing show how the hollows of the skull are filled by the spheres of the eye and by the bulky muscles that activate the lower jaw. The cartilage and soft tissue of the nose are the main additions to the basic bony form. Note also the position of the lips and temples.*

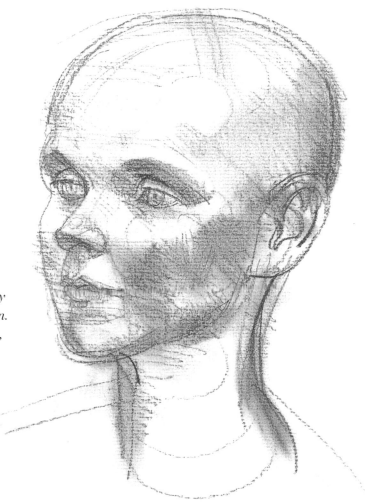

Covering the skull

RIGHT: *All the rest of the tissue that covers the skull is relatively thin, consisting mainly of the scalp and facial muscles of expression. The lips may have some additional fullness, as do the external ears.*

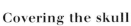

Flattening occurs on the forehead and the temples.

The side plane on the nose reflects the side plane of the head.

The red line defines where the frontal plane meets the side plane.

Flattening

LEFT: *Although the skull fits into an ovoid form, there is some flattening in certain places, notably on the temples and the facial area. As a result, the frontal plane of the face turns through nearly a right angle to the plane of the side of the head.*

13

Searching for the form

With the knowledge of the skull shape fresh in your mind, I suggest that you now try to make some studies from a subject with hair cropped close to the head, or even with no hair at all. Failing that, tie back or bind the sitter's hair really tight to the scalp. The object of this exercise is to search out the relative sizes of the facial and cranial areas as they appear from different viewpoints, so concentrate on these proportions almost to the exclusion of all else at this point.

Connecting the facial features with a triangle (see opposite, far right) will help you to place the facial area on the front plane and to gauge its size against the broad side planes. Look for any geometric shapes that you can impose to help judge the distances and directions; it is hard to assess these proportions without some impartial measurement, as your brain refuses to believe that the face can occupy such a small area of the whole head. Do not worry about producing a likeness at this stage, just concentrate on the big forms and the proportions.

Drawing from sculpture

Live sitters can never remain completely still for very long. The portraitist has to accept this, and indeed it becomes less of a problem as you become more proficient and confident. Initially, though, it is very helpful to make studies from sculpted heads. In addition to the fact that they do not move, however long you take on your drawing, usually they are all just one colour. One particularly useful attribute is the solidification of hair forms in sculpture: all you have in front of you is form, pure and simple.

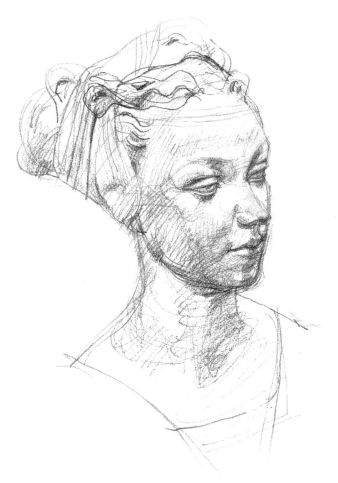

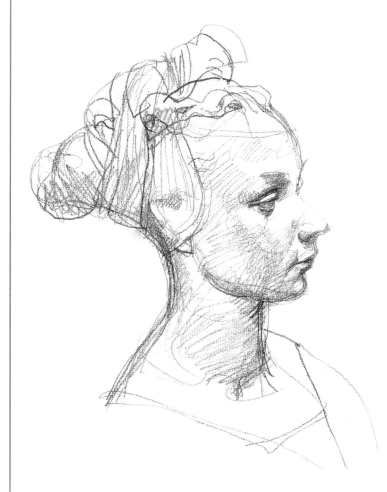

Sculpture studies

This beautiful head, drawn from a sculpture in the Victoria & Albert Museum in London, clearly reveals the forms of the underlying skull even though her bound hair extends the cranium.

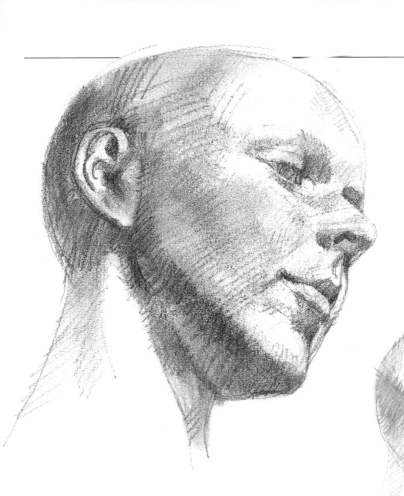

Studies from life

LEFT AND BELOW: *The view of the facial area and its relationship to the cranium is much altered by a change in eye level. The previously observed ovoid form is now poised on the neck, but from this viewpoint the cranium is much diminished. I have imposed a triangle to show the positioning and relative importance of the facial features.*

The cranium appears smaller viewed from this eye level.

The triangle here shows the relationship of the facial features within the ovoid head.

The underside of the jawline makes an almost straight line to the back of the head.

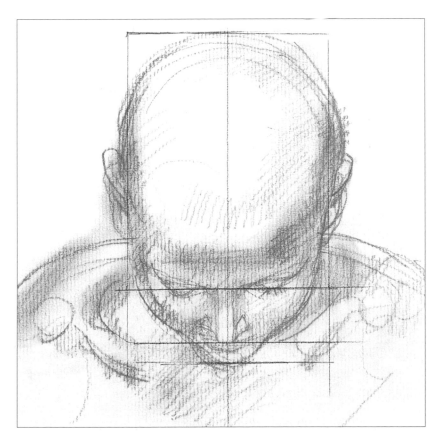

Top view

LEFT: *This view from above has the opposite effect to the head viewed from below (see above), diminishing the facial area and enlarging the amount of cranium that can be seen. Note, also, how the cranium is broadest above the ears, narrowing at the temples.*

15

Placing the features

*The facial area, the vaguely triangular shape that contains the features
– eyes, nose and mouth – occupies a relatively small part of the total
head surface. Within this area, however, there are many variations,
and it is vital that you look out for them.*

THE RELATIONSHIP OF the facial area to the head tends initially to be age-related: at birth and in infancy the features are concentrated in one small area, and as the skull grows larger the proportion of head to face begins to change, the face gradually occupying a greater proportion of the whole. However, this change is neither constant nor predictable – adults who retain a relatively small facial area are perceived to be 'baby-faced', and late growth of the lower jaw may produce an unusually long, 'horsy' face. Search out this basic relationship of facial area to head, and you will discover almost limitless variations.

Next, look within the facial area and see the distances and shapes found there, too. Imagine that there are lines that join up the features; even draw them in, as shown on these pages, and take note of the geometric forms that result. But above all, do not rely on preconceived theories of facial spacing – always look for yourself.

Using positional grids

In the drawings on this page and the one opposite, I have drawn a grid to mark the levels of eyes, nose and mouth within the frontal area. The red line denotes the halfway mark. These grids are not meant to be a system for predicting proportion – they are more an indication of the average types. When studying a head, look out for differences in shape, the relationship of the features and your viewpoint.

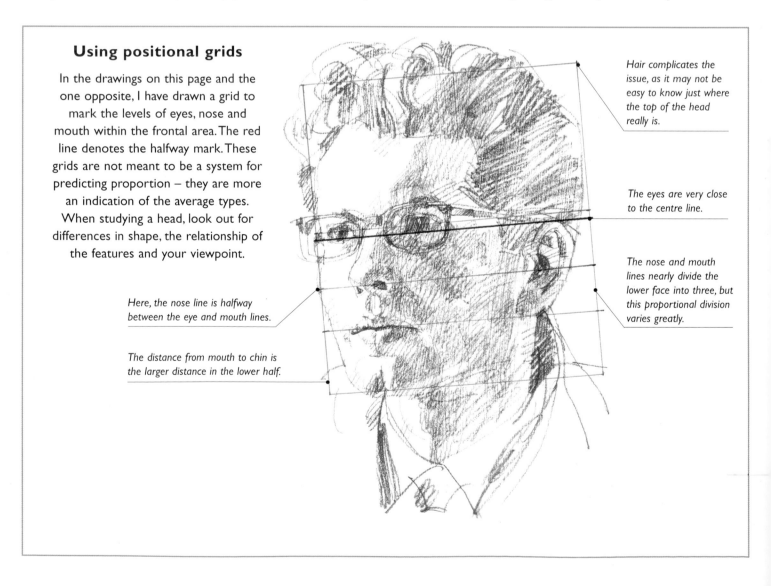

Hair complicates the issue, as it may not be easy to know just where the top of the head really is.

The eyes are very close to the centre line.

The nose and mouth lines nearly divide the lower face into three, but this proportional division varies greatly.

Here, the nose line is halfway between the eye and mouth lines.

The distance from mouth to chin is the larger distance in the lower half.

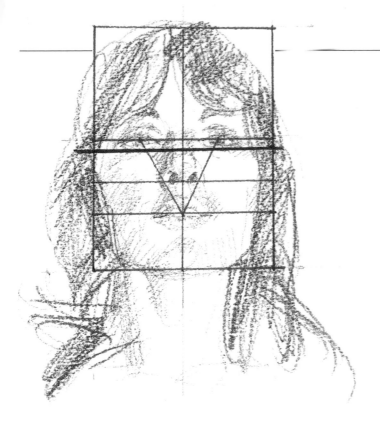

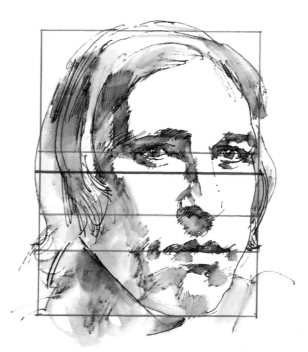

The longer face

BELOW: *In this adult face the eyes are well above the halfway mark. This is mainly because the mouth-to-chin distance is long, but also observe the length from the base of the nose to the eyes.*

Using triangles

ABOVE: *An especially useful drawing aid is an imaginary triangle drawn through the eyes and the centre of the mouth; it is much easier to judge small differences in such a triangle than it is to measure distances by eye alone.*

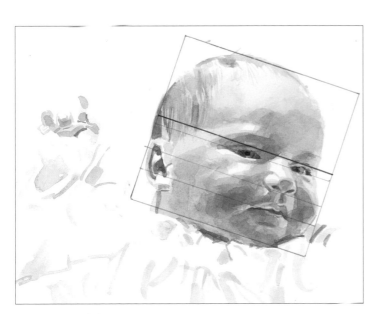

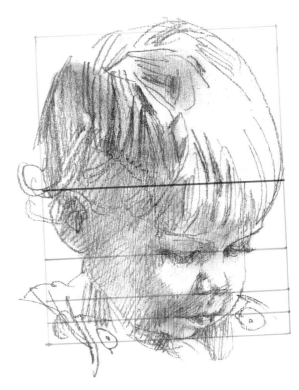

Babies' features

ABOVE: *The eyes of this baby are below the halfway line: from a slightly higher viewpoint they could be expected to be even further below halfway, thus concentrating the features into a very small area.*

Growing up

ABOVE: *The same concentration of features demonstrated in the baby's face on the left is seen in this three-year-old – even more so, in fact, as a result of the higher eye level.*

The eyes

Eyes are the most distinctive of the facial features, conveying the emotions and character of your sitter. Look closely at how they are set in the head and the shape of the lids as they curve over the eyeball – it is these features that give the eyes their individuality.

A PERSON'S EYES ARE probably the most immediately noticed facial features. As an organ, except for variations in iris colour, one human eye looks much the same spherical shape as any other, so the enormous variety of shape that we see in life is due to the framing by the eyelids and their lashes. The eyes can speak eloquently about mood and character and are key elements in any successful portrait, but take care not to over-emphasize them. You may have seen some paintings in which the artist has placed a brilliant highlight in or near the pupil. This makes the eye look very fluid and shiny, but you should use this technique only when you can truly see the highlight.

When painting a portrait, think about the colour of the irises and the size of the pupils, the direction that the eyes appear to be looking and the feeling that they convey. The pupil always appears near the centre of the iris, whatever the viewpoint.

The anatomy of the eyes

The eye itself is spherical, producing a convex bulge in the concave eye socket. The normally visible 'white' of the eye is a small part of the complete eyeball. If you take this into consideration, it is easier to see the form of the eye and to understand how the covering eyelids follow this form. The upper lid is more mobile than the lower one.

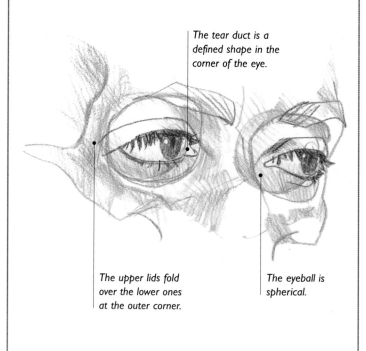

The tear duct is a defined shape in the corner of the eye.

The upper lids fold over the lower ones at the outer corner.

The eyeball is spherical.

The shape of the eyelids

BELOW: *When the eyes are turned one way or another, look very carefully at the changes that occur in the shape of the eyelids. Often, the eye nearest to whatever is being observed will be very slightly closed, exposing less of the white of the eye. The far eye also tends to be turned a little more.*

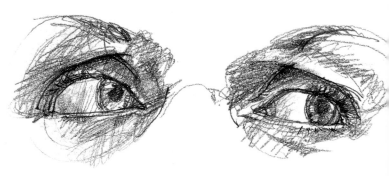

Looking to the left

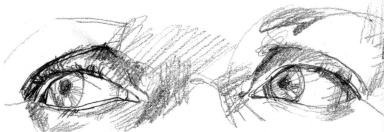

Looking to the right

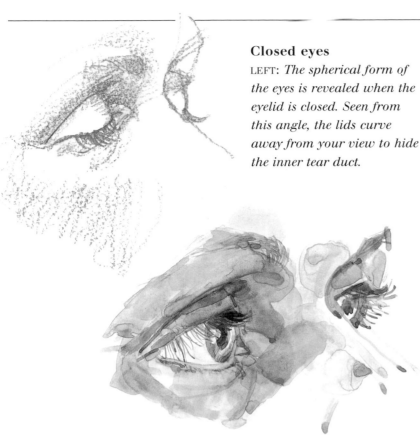

Closed eyes

LEFT: *The spherical form of the eyes is revealed when the eyelid is closed. Seen from this angle, the lids curve away from your view to hide the inner tear duct.*

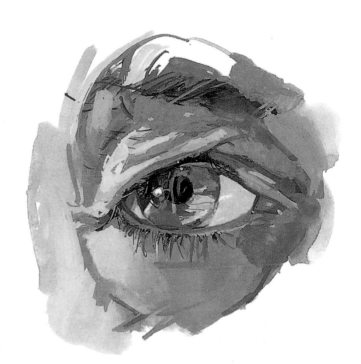

Open eyes

ABOVE: *When the open eye is viewed other than straight-on, the spherical form is very clear. It is important to think about the relationship of the eyes to other facial features, such as the bridge of the nose, which obscures part of the far eye.*

The colour of the eye

ABOVE: *Close-up examination of the eye, especially the iris, is both fascinating and informative. The 'white' of the eye is not pure white; it is often shadowed and may reflect a bright highlight.*

Practice Exercise: DRAWING THE EYES

It is generally better to draw both eyes when making a study: they work as a pair and reflect each other's shape.

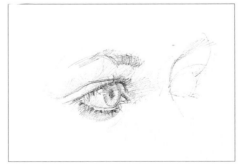

1 *As lightly as possible, using lines just dark enough for you to be able to see them, mark where you judge the eyeballs to be. Then make your first indications of the lids that wrap around them.*

2 *Indicate the thickness of the eyelids, revealed by the edges inside the line of the lashes. Place the pupils and the surrounding iris – the pupil always appears near the centre of the iris, even from the side.*

3 *Complete the far eye, indicating the position of the nose. It is important to measure the space occupied by the bridge of the nose; here it is almost the same width as the near eye. Inset: The inner corner of the far eye is obscured by the top of the nose.*

The nose

There are as many shapes, sizes and forms of noses as there are people. Because the nose is the most prominent external facial feature – hence the saying 'it's as plain as the nose on your face' – even the smallest change in pose by a sitter will affect how you portray the nose.

To ANALYZE A PARTICULAR nose, look at the prominence of the bridge and the sharpness of the angle that it makes with the plane of the face (see page 13). This gives the first definition of the type of nose. A high bridge is typical of the Roman, aquiline or hooked nose, and the associated fleshy part tends to be relatively narrow. In direct contrast to this, you may find that a broad lower part of the nose is associated with a lower bridge, particularly on wide noses.

Try to find flat planes on the lower nose, even though there may seem merely to be rounded forms. The essential thing is to look at the planes of the nose and to render its slopes and plateaus clearly – do not let pre-conceptions get in the way of direct observation. Remember that the fleshy part of the nose is not formed from bone and is therefore more malleable. Highlights on noses are a result of the sharp angles of bone and cartilage, and the smooth, slightly oily skin over the top.

The anatomy of the nose

The simple, annotated anatomical diagram of the nose below shows the basic structure: the bridge or upper section is formed by the nasal bone, while the lower part is more malleable and fleshy. This arrangement of flat plates of cartilage and soft tissue affords a great deal of scope for diversity of form.

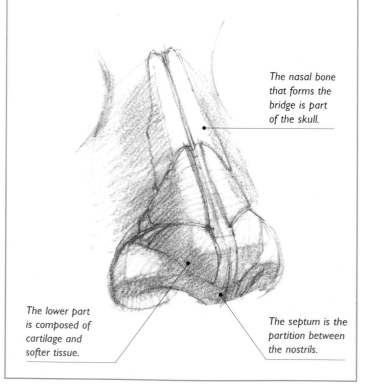

The nasal bone that forms the bridge is part of the skull.

The lower part is composed of cartilage and softer tissue.

The septum is the partition between the nostrils.

Wide nose

ABOVE: *Although, of course, there are exceptions to this rule, a typical wide nose can be simply characterized by having round, quite wide, nostril openings and a low bridge.*

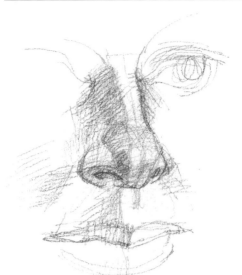

Chiselled nose

LEFT: *This kind of nose is recognized by its high bridge and the flat planes that lead up from the cheeks. Here, the septum has a clearly defined central cleft or division; this is more pronounced in some noses than others.*

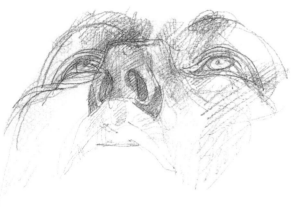

Unusual angle

RIGHT: *From this view, the line of the bridge of the nose is horizontal and very short, and the slope from the bridge to the cheek is nearly vertical.*

Nose in profile

ABOVE: *In this view, the immediate impact is of the rounded-over cartilage and fleshy tip. The connection from the nose to the cheek muscle and the curl of the narrow nostril are prominent. Note the distance from the high bridge to the eye.*

Practice Exercise: DRAWING THE NOSE

Making your study drawings oversize is a good way to examine the structure of the nose and its relationship with the surrounding features.

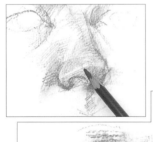

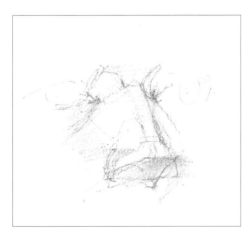

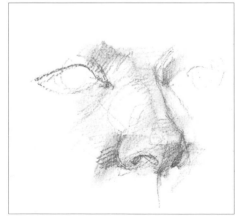

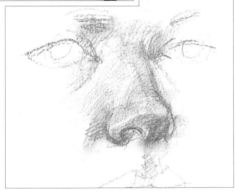

1 *Lightly begin the structural blocks that make up the nose – the slope up from the cheek to the bony bridge, the tear ducts for the position of the eyes and the space between the eye pouch and the top of the nostril. Leave the underside of the nose as a rhomboid shape.*

2 *With the structure in place, look at the actual nose you are drawing. I made more definite marks to indicate the broadness where the top of the nose joins the forehead, and used hatching and smudging to show the interior and exterior curves of the nostrils.*

3 *Here, the crosshatching and hatching strengthen the contours of the sweep from the cheek to the top of the bridge, and I darkened the septum at the base. A faint indication of the upper lip gives proportion to the whole. Inset: Highlights and shading strengthen the forms.*

The mouth and teeth

The most mobile of the facial features and probably the most immediately expressive, the mouth demands a degree of special attention from the portraitist, due both to its underlying structure of jaws and teeth and to the flesh on top.

THE MOST OBVIOUS INFLUENCE on the form of the lips is the curve of the two rows of teeth that they overlay; protruding teeth make a protruding mouth. The second thing to look for is the degree of fleshiness, the fullness of the lips. The sitter's expression has some influence on this, hence 'tight-lipped' and pouting, but the largest differences are due to race, gender and age. Upper lips tend to be rather more prominent than the lower, but this is not always so.

The lips lie on the same plane as the front of the face until they dive into the hole that is the mouth. It is easy to see the lips as disembodied, like the smile of the Cheshire Cat, but it is only quite small changes of form, and the change of colour to pinky-red, that distinguish them from the rest of the face. Even the slightest change in tension of the muscles surrounding the mouth has an immediately recognizable effect on the expression of the face, even when the mouth remains closed.

The anatomy of the mouth

The external mouth is simply a continuation of the inner mouth folded over to a varying degree to form the lips, which lie in close contact with the teeth or the bony arches of the jaws beneath and reflect their forms. Observe carefully the distance between the upper lip and the nose, and that between the lower lip and the chin.

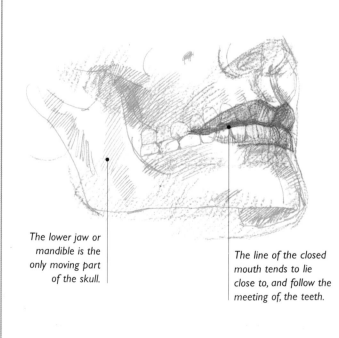

The lower jaw or mandible is the only moving part of the skull.

The line of the closed mouth tends to lie close to, and follow the meeting of, the teeth.

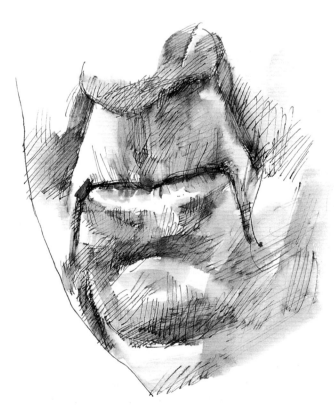

Older mouths

ABOVE: *With age, the surrounding features can affect the mouth itself. In addition to the thin upper lip and protruding lower one here, there is a pronounced downward fold from each outer corner; the jowls are also prominent.*

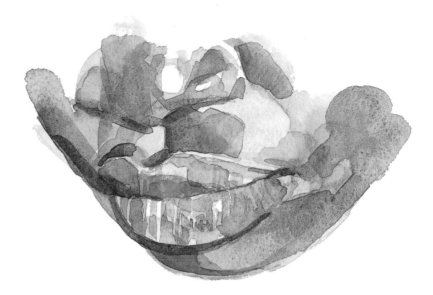

Profile view

LEFT: *Seen from the side and from slightly above, the upper lip here is scarcely more than a line and the form below the lower lip cuts into that of the chin.*

Full lips

ABOVE: *In very full-lipped mouths there is often a sharp demarcation of the edges of both the upper and lower lips. Here, part of the upper lip has a flat, almost concave plane.*

Practice Exercise: DRAWING MOUTHS

This exercise offers you a chance to combine drawing the lips and teeth in repose and to concentrate on the relationship between them.

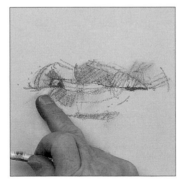

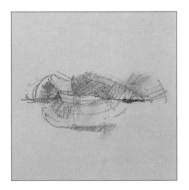

1 *Establish the form of the lower lip and upper lip, which has three parts: the central 'Cupid's bow' and the two outer parts that drop to the corners of the mouth. The teeth are lightly defined, and I marked the corners of the mouth and the cheek on the near side.*

2 *Now that the structure is established, start to look closely at the contours and colour of the lips, which are never uniformly pink. Adding the lightest pastel shades sets the palest tones across the lips.*

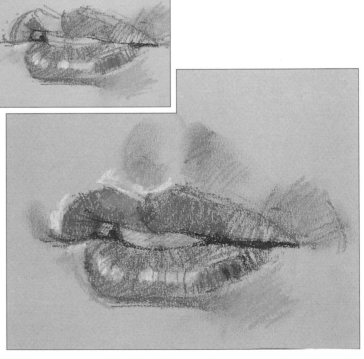

3 *The corners and inside of the mouth are never black; I used a hot red here, and then smudged in the colour of the teeth. Finish by suggesting the curves of the skin around the mouth. Inset: The sheen on the lips is a pale highlight.*

23

The ear

Beginners often experience almost as much difficulty in drawing the human ear as when drawing hands and feet. All too often the ear is drawn as an indeterminate, cabbage-like form, whereas in fact it has a very precise structure that is intrinsically the same in every individual.

THE ANNOTATED DIAGRAM BELOW shows the principal features of a typical ear. Just as with the nose, there is no need to learn the names of the parts of the ear; they are included only so that you will know the areas that are mentioned here. There are variations between individuals of course, but these concern the placing of the ear on the head and the relative size of its component parts. The lobe, to give one example, is sometimes quite long, and at other times can be very diminutive.

Some ears lie flat, while others stick out from the head. The ear often aligns with the eye and the base of the nose, and this is a good thing to check, but this is another 'rule' upon which you should not rely absolutely without observation. Although the position of the ears is usually more or less identical on each side of the head, there may be differences: your sitter may have asymmetrical ears, with one noticeably higher or lower than the other.

The anatomy of the ear

Every ear has an outer fold, or helix, that runs around the outer edge and then dives down and into the inner concha, the central cavity. A similar inner curving fold, known as the antihelix or anthelix, eminates from the tragus, the lump or prominence on the inner edge of the ear.

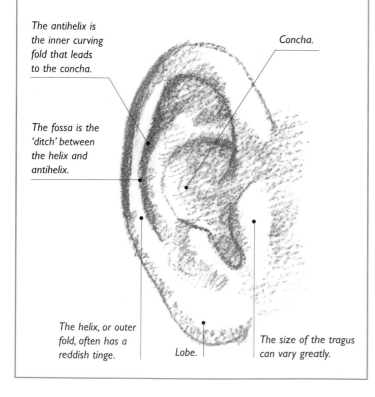

The antihelix is the inner curving fold that leads to the concha.

Concha.

The fossa is the 'ditch' between the helix and antihelix.

The helix, or outer fold, often has a reddish tinge.

Lobe.

The size of the tragus can vary greatly.

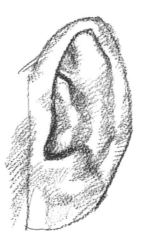

Flat ear
LEFT: *The tragus and the upper arch of the helix join to make an unusual continuous form, the antihelix has a sharp edge by its fossa, and the whole ear is flattish.*

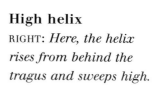

High helix
RIGHT: *Here, the helix rises from behind the tragus and sweeps high.*

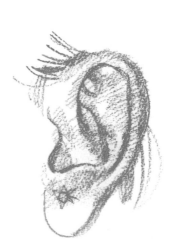

Large lobe
LEFT: *The helix rises from the centre of the concha, the upper curve is quite low, and the lobe of the ear is pendulous and flat.*

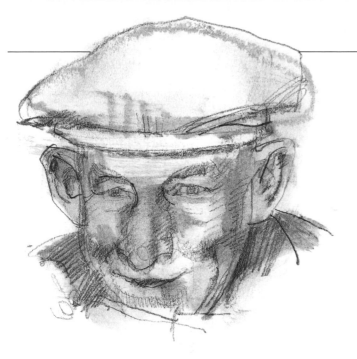

Frontal view

ABOVE: *The most noticeable variations are found in the shape and size, and in how the ears stand in relation to the head; wide or sticking-out ears are obvious features, but be careful not to lapse into caricature.*

Babies' ears

BELOW: *Even on the rounded skull of a baby, the position of the ears in relation to the other features and the whole head is the same as on an adult. Infant ears have simple rounded forms.*

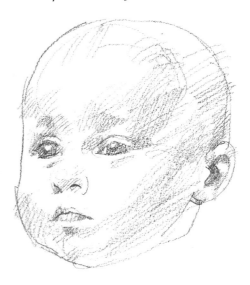

Practice Exercise: DRAWING THE EAR

Using colour washes allows you to define the different parts of the ear through tone. See opposite for definitions of the terms used.

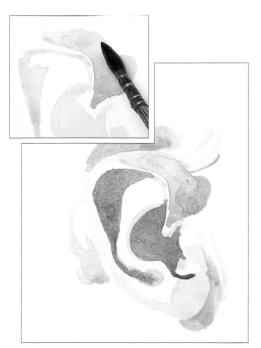

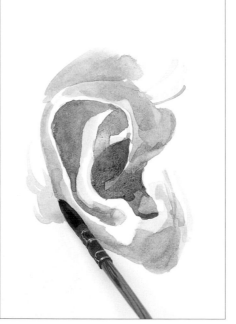

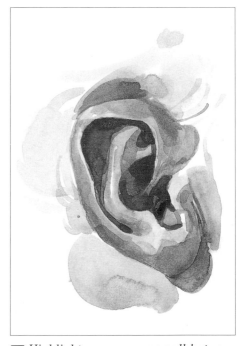

1 *Establish the position of the tragus, then begin to define the helix, fossa, antihelix and concha. With the shapes set, add the darker hot skin tones and the contrasting cooler shadows. Inset: The first wash for the helix is very pale.*

2 *Look for the details that make each ear unique. Here, there is an inner fossa inside the antihelix, the area that leads into the auditory canal is quite cool, and I painted the outside edge of the helix in a very hot tone.*

3 *Highlights on ears are small but can often be strong. By adding darker tones, you can leave the lighter washes as highlights. I reinforced the cooler areas around the lobe and the structure around the concha.*

Hair shape

Just as with the features, the shapes of the skull and head hair are unique to each individual. Clearly, it is not practicable to try to draw every hair on the head, but in the same way as single leaves on a tree can be clumped together visually, groups of hairs combine together into identifiable composite forms.

WHEN DRAWING ANYTHING, it is absolutely vital that after you have closed into the drawing to concentrate on detail, you then draw back, widen your view and check that the details are in all the right places. In this vein, having looked at the details of facial features in the previous pages, return to drawing the whole head, but this time paying particular attention to the hair.

Try to sense the overall shape and volume and, within that, the main directions of hair growth. A smooth head of straight hair resembles a helmet in the way that it mimics the shape of the cranium, and can be drawn as such. Thicker, curlier hair presents a little more difficulty, but the same principle applies: you must find generalizations, much in the same way that a sculptor does when dealing with the problem. Only where strands or swathes of hair escape the general form do they need to be drawn individually, when they will also help to suggest detail that is missing elsewhere.

Hair as structure

To portray frizzy or very curly hair, or hair that stands away from the head, successfully you may need to look at it as main masses that have – for the purposes of studying them – a separate existence from the cranium and facial features. Below, the sketch on the left is an explanation (not a preliminary stage, as in the step-by-step exercises in this book) of the mass and area of the hair in the drawing on the right.

Study of hair volume and mass

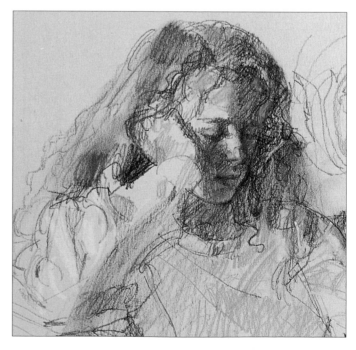

Finished portrait study

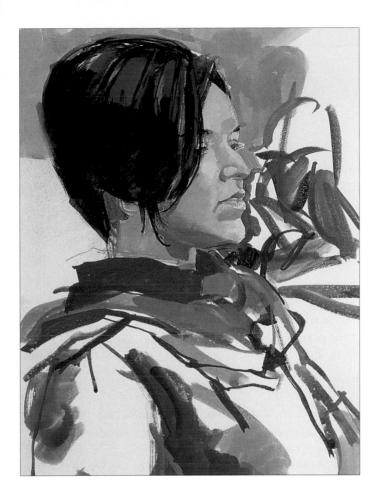

Loosely following contours

LEFT: *In this painting the hair acts like a skull cap, reflecting the shape of the cranium, while at the same time flopping down to obscure much of the face.*

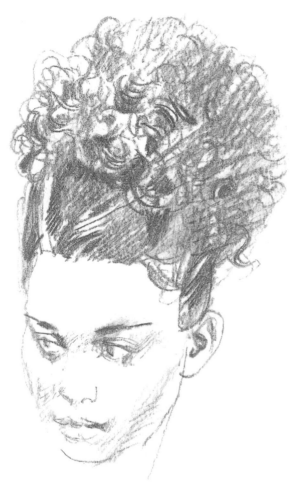

Big hair

ABOVE: *Extreme hairstyles can have their own form, which may be almost independent of the shape of the head. While never losing sight of the fact that such hair is still attached to the head, it may be necessary to treat it as a new, unknown entity, and to search out its volumes afresh.*

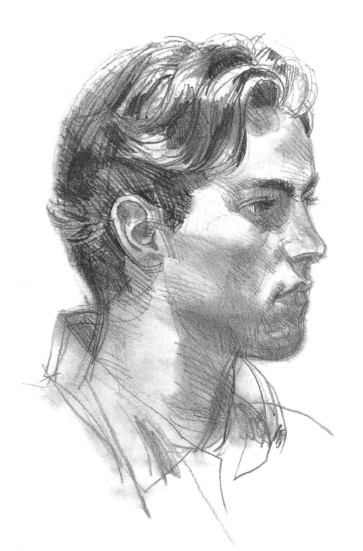

Catching the wave

LEFT: *Sometimes, as here, a head of hair may have one form that only loosely conforms to the shape of the skull. To describe such a wave, look first at the shadow under the crest as it springs from the scalp and how it catches the light as it turns over, then see it flop down into shadow, catching the light again as the ends turn up.*

Facial hair

For the most part beards, moustaches and eyebrows need to be thought of and treated in the same way as head hair – that is to say, as generalized forms rather than as a mass of thin lines that represent individual hairs.

A CASE COULD BE MADE out for rendering sparse facial hair with single lines, especially when painting a much enlarged portrait. In this situation the eyebrows could also best be drawn by rendering them with lots of tiny lines; as with much else in drawing and painting, there is no absolute rule that must not be broken. But if nothing less than drawing in every hair will do, you are committed to the same close scrutiny of everything, and you may even have to draw in the pores of the skin!

However, most of us are happy to draw and paint with a more impressionistic vision, and the thicker parts of eyebrows, moustaches and so on can be put in quite boldly, the sparser sections being rendered with another paler colour and then perhaps breaking down into single lines. The shaved areas on the face of a man, especially if he is dark-haired, are likely to have a blue or grey appearance, as will areas of short stubble. As always, observe closely rather than relying on assumptions.

The eyebrows

Eyebrows are often portrayed as little more than lines or smudges of colour following the orbital arch of the skull, but they may be abundant enough to have form of their own. The sheer number of angles at which the hairs may grow makes a detailed study worthwhile. In the examples below, note the different treatments of the hairs nearest the nose.

Solid forms

Showing separate hairs

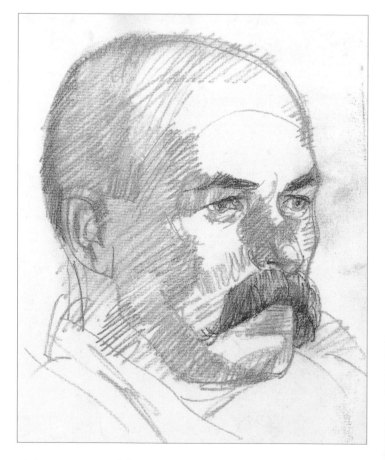

Using tone and form

ABOVE: *In a reversal of the usual cranial arrangement, shaved or absent head hair has no form but can be indicated by colour or tone, while the luxurious moustache must be drawn to bring out its form.*

28

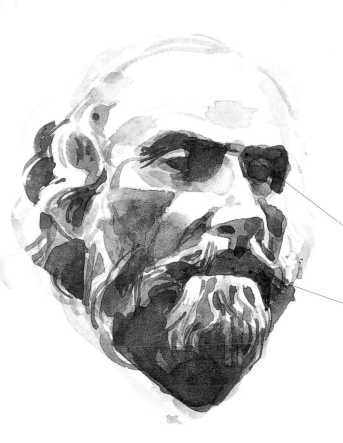

Using lighting

LEFT: *Under strong lighting from above, the eyebrows can virtually disappear, while the moustache and beard may take on a sculptural quality. Here, the masses of the facial hair have been treated in exactly the same manner as the other forms, that is, modelled by light and shade.*

The strong cast shadows start at the ridge of the eyebrows.

The deep shadow leaves the actual shape of the mouth to be inferred.

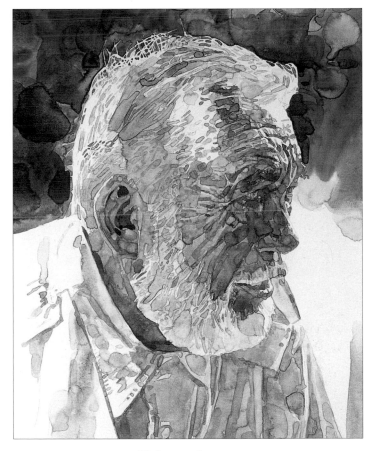

Stubble

BELOW: *Because very short facial hair, stubble (otherwise known as five-o'clock shadow), has virtually no form of its own, it is best depicted mainly by its colour.*

The form of the face can still be seen through the stubble.

Where the form of the stubble turns away from the eye, the compression of the short hairs makes a darker edge.

Using colour

ABOVE: *Head and facial hair that is white or very light grey reflects colour in a different way from yellow, brown, red or black hair. The contrast between the highlights and reflections on the white hair, shirt and jacket, and the tanned, lined face brings dynamism to this portrait.*

29

Bringing it all together

In the previous pages, the main concern has been with drawing and painting the individual parts of the head and features, based on their structure and anatomy. This exercise demonstrates how to bring everything together in a complete portrait head. One of the most important things to remember while working is to assess continually whether or not the features are in their correct position, both in relation to each other and to the head as a whole. Here, the secret is to be ready to revise your drawing until you are satisfied that it all hangs together, and to remember that, whatever the 'rules', nothing can be taken for granted without checking.

1 *Lightly tick in the main features, using lines through the centre of the nose and across the cheekbones as initial guides. Inset: Establish the size of the eyes and the distance between them. At this point I realized that I had exaggerated the length of the nose. Making new marks to correct this meant that I also had to amend the lips.*

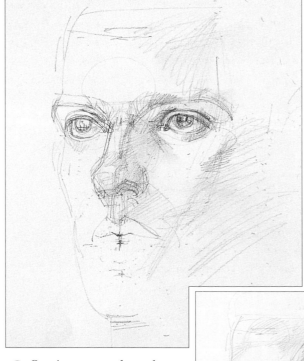

2 *Continue to work on the frontal plane of the face, giving some preliminary indication of the cranium, ear and stance of the neck. Note that the outline of the head has not been put in – if you can leave it until later in the drawing, it should not need any amendment. Inset: Some shading was used to indicate the turn of the frontal plane across the cheekbones.*

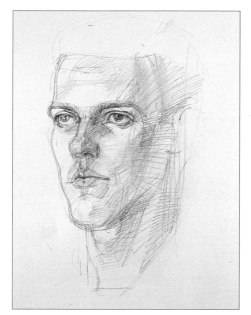

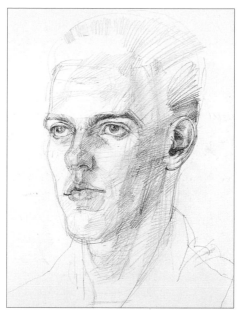

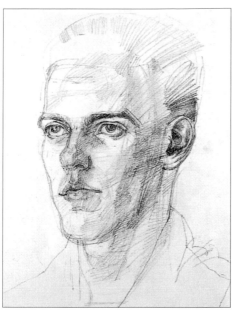

3 At this stage I made minor adjustments to enlarge the eyes a little and set them closer together. I also began to add detail around the nose and mouth and in the ellipse of the chin. Broad shading begins to define the side plane of the face.

4 The position of the ear is critical, so check the alignment with the frontal features. In this instance it aligns with the top and bottom of the nose. Some indication of the shoulders and the hair was also made at this stage.

5 When you are satisfied with the form of the ear, start to strengthen the tones. I used some crosshatching to emphasize the shadow on the edge of the cheekbone and thus give it more prominence than the lower shadows.

6 Short pencil strokes that followed the hair direction, combined with some hatching, were used to depict the sitter's short hair. The final outline of the cheek and jaw have been drawn in, as have the collar and V-neck of the shirt. Note where the line of the collar intersects with the neck; if you position it too low, it has the effect of elongating the neck.

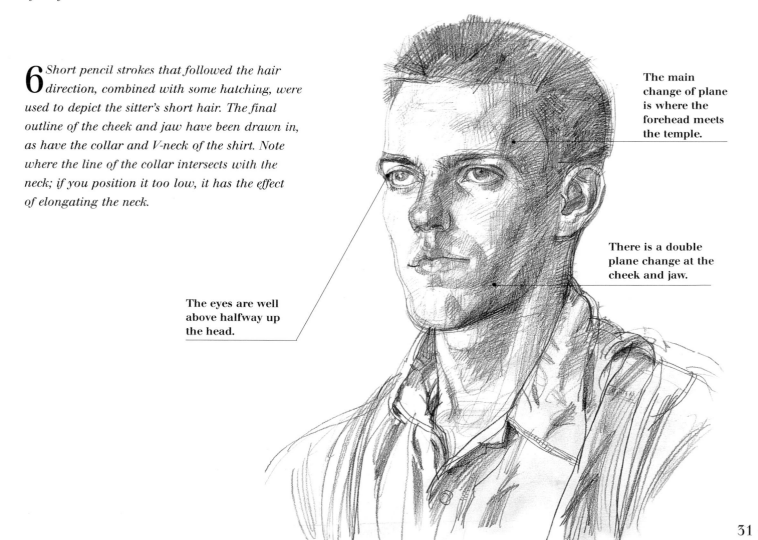

The main change of plane is where the forehead meets the temple.

There is a double plane change at the cheek and jaw.

The eyes are well above halfway up the head.

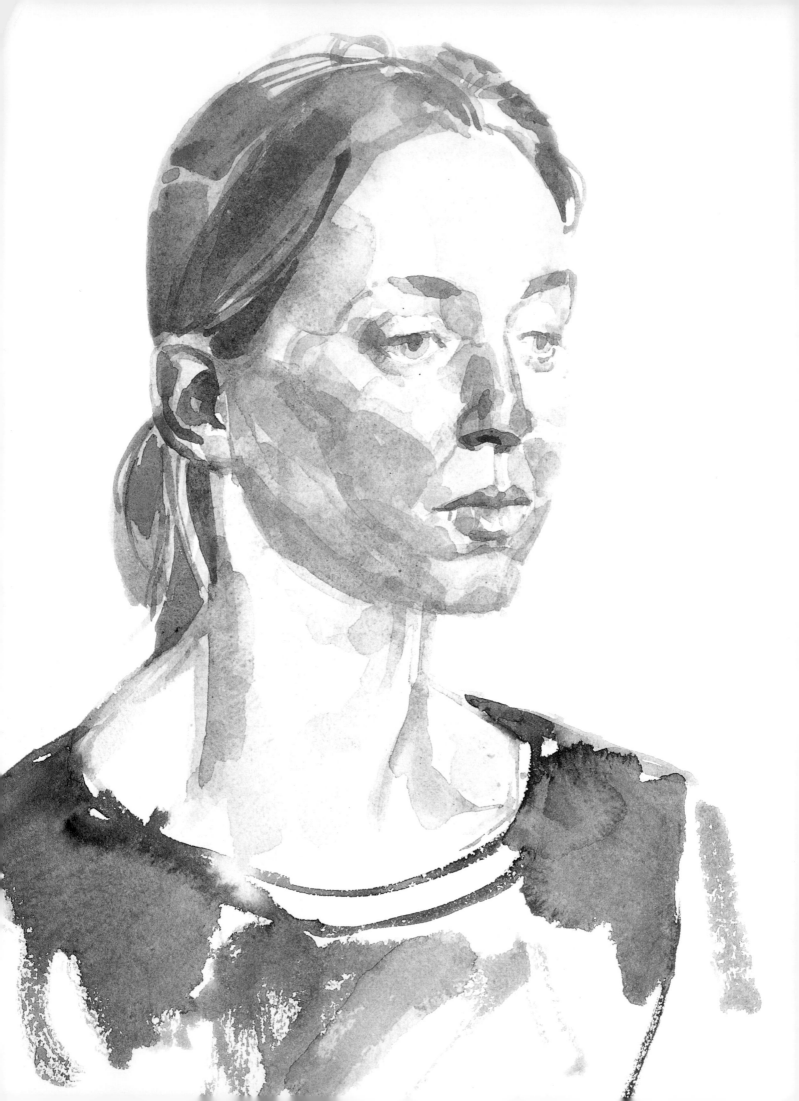

Skin and Hair Colour

In people of all ethnic origins, there is
a massive variety of hues, tints and shades to
be found in skin and hair colours. In addition,
there can be extraordinary variations and
contrasts in each individual, from blue
highlights on black hair to cool, green cast
shadows on a pale skin and hot, dark-purple
ones on a dark one. Seeing and recording
colours accurately is an essential part
of achieving a good likeness.

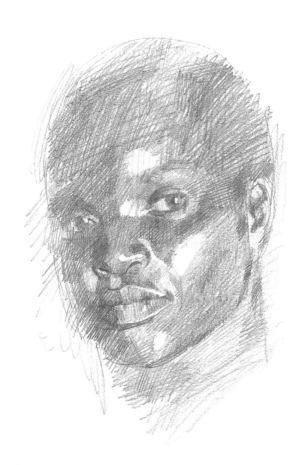

Colour

Understanding how colours interact and knowing the concept of colour temperature are vital if your drawings and paintings are to work; in portraiture, skin and hair colour, shadow areas and highlights are all dependent on accurate observation and use of colour.

THE SPECTRUM OF light visible to the human eye has red at one end and goes through orange, yellow, green and blue to violet at the other. We refer to the colours in the section from red to yellow as 'warm', and of those in the part from green to violet as 'cool'. It is accepted that some colours seem to be warm and others to be cool, but in reality, objects that are red and orange are not necessarily warmer to the touch than objects that are coloured green or blue.

Of course, the apparent colour of any object is also affected by the intensity and colour of the light that illuminates it. Shadowed areas, receiving only reflected light, are often cool in colour, while the areas on which direct light is falling are warm. It may be the other way round at times, the shadows being warm and the light areas cool – the important thing is to watch out for these temperature changes and use them to define light and shade, and to add excitement to the colour.

When laying out pigment on your mixing palette, follow a system so that you always know where to find each colour. In my palette layout, shown here, the colours arc in one direction in increasing degrees of warmth from the centrally placed white, and increasingly cool in the opposite direction. Thus, it is easy to keep areas of cool mixing separate from warm ones; the pigments that are placed close together will mix harmoniously, while those that make grey when mixed are kept apart.

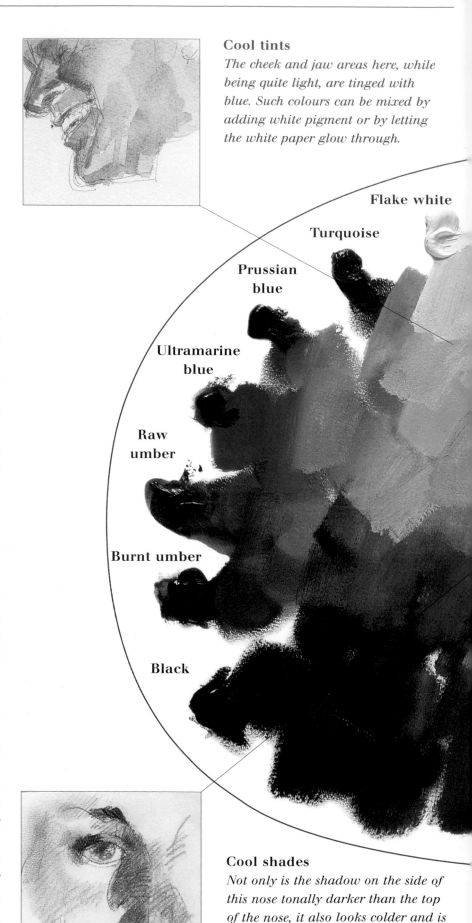

Cool tints
The cheek and jaw areas here, while being quite light, are tinged with blue. Such colours can be mixed by adding white pigment or by letting the white paper glow through.

Flake white

Turquoise

Prussian blue

Ultramarine blue

Raw umber

Burnt umber

Black

Cool shades
Not only is the shadow on the side of this nose tonally darker than the top of the nose, it also looks colder and is mixed from the colours in the cool end of the palette without using white.

Warm tints

These are warm hues mixed with white, used for the lit areas of this ear. Both the shadows and the light areas of ears are frequently warm or even hot in colour.

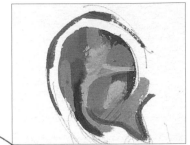

Titanium white **Naples yellow** **Lemon** **Mid-yellow** **Indian yellow** **Cadmium orange**

Raw sienna

Burnt sienna

Vermilion

Magenta

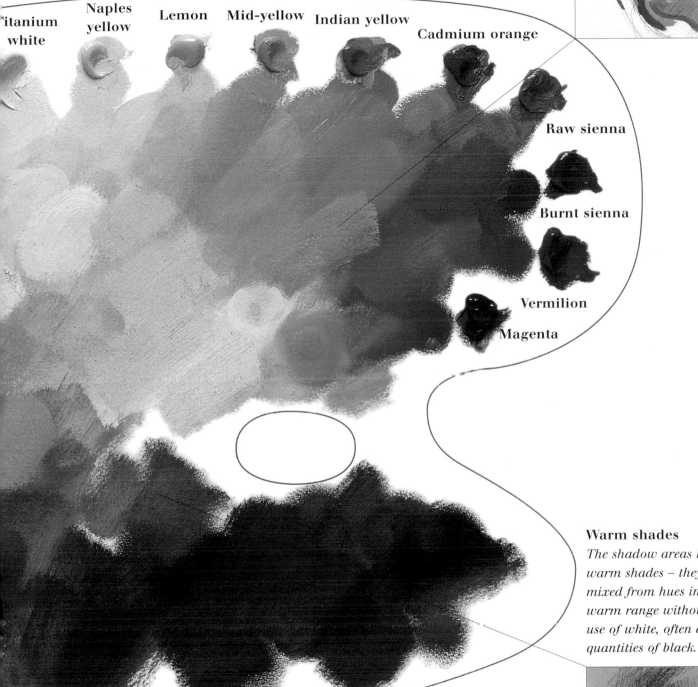

Warm shades

The shadow areas here are warm shades – they are mixed from hues in the warm range without the use of white, often adding quantities of black.

Warm and cool skin colours

On the human face and body, an area that is suffused with blood not only becomes redder in colour but is also physically warm. In contrast, colder areas appear to be bluer: for instance, hands are described as being 'blue with cold'.

COLOUR CHANGES CAUSED by suffusion of blood are very clearly seen in people whose skin colour is light and translucent. To give yourself the best chance of observing these kinds of variation, choose a light-skinned subject with blond or red hair and blue eyes. The redness of the cheeks is likely to be unmistakable, but the bluish or greenish tinge to the cool areas may be much more subtle, indeed almost imaginary, and may be dependent on individual interpretation.

Nuances of colour are often lost in photographs, especially in the shadow areas. With a sitter, the pupils of your eyes open up as you look into the shadows and allow you to make a judgement of the colour you are seeing. If you sense even the smallest trace of a colour bias, it is acceptable to exaggerate it. In films, you will often see bright shadows of blue, green, orange, purple, and so on. We accept these as being normal solely because the lit areas are the expected 'flesh' colours.

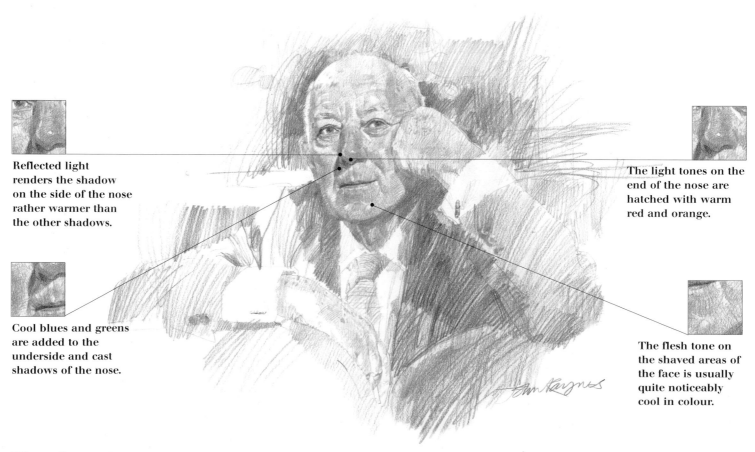

Reflected light renders the shadow on the side of the nose rather warmer than the other shadows.

Cool blues and greens are added to the underside and cast shadows of the nose.

The light tones on the end of the nose are hatched with warm red and orange.

The flesh tone on the shaved areas of the face is usually quite noticeably cool in colour.

Warm lips and nose
ABOVE: *This drawing was made using coloured wax pencils. In addition to the interplay of reds and blues in the background, the hatched colours on the face, in both the light and shadow areas, show variations of colour temperature.*

Practice Exercise: WARM AND COOL SKIN

When making a study of skin colours, arrange your sitter and the lighting carefully; here, the light source is on the front and far side of the face.

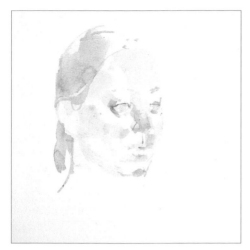

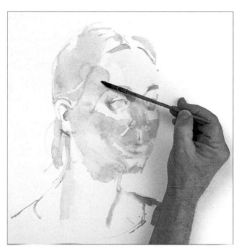

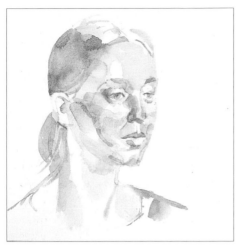

1 *Use a very watery wash of cool colours to establish the near side plane, the temple and the roundness of the eye. The nose and cheeks use a similar wash, this time of warm colours. The yellowish forehead is neutral.*

2 *I applied stronger – but still pale – washes, as much to fix the relationship of the features as to suggest the skin colours; the ear is hot and the eyebrows are cool. The cool washes of the jawline go into the yellow-green of the neck.*

3 *When defining the mouth and pupils of the eyes, keep them light so they can still be changed. Next, I began to strengthen the washes and apply warm over cool and vice versa, while leaving the paper clear to indicate highlights.*

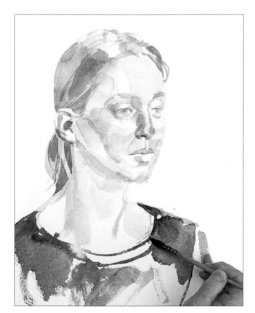

4 *With the features in place, I looked afresh at their colours in the light area: it is better to use a strong, hot colour for the nostril, rather than black. Colour temperature changes are subtle, but it is quite legitimate to exaggerate even slight hints of colour if you see them there.*

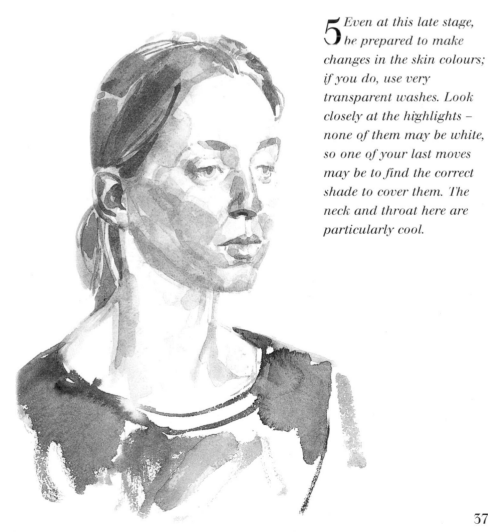

5 *Even at this late stage, be prepared to make changes in the skin colours; if you do, use very transparent washes. Look closely at the highlights – none of them may be white, so one of your last moves may be to find the correct shade to cover them. The neck and throat here are particularly cool.*

Tanned skin

*Although people with naturally dark or tanned skin may have less
obvious variations in colour than the paler Caucasian skin, capturing
the colours accurately requires just as much subtlety and careful
observation. There are many different hues of tanned skin.*

THE LOCAL COLOUR changes that are so visible in transparent white complexions are far less easily detected in more pigmented skin. Pale skin darkens when exposed to sunlight (except for albinos), and this tanning is often accompanied by freckles or redness in areas such as the nose and forehead.

Mediterranean or Latin skin, however, is permanently pigmented, and as a result it is more evenly coloured and appears generally to be warmer in colour, with no hot patches. At its palest, in winter or in a cool climate, while never as blue-white and pink as that of the typical Caucasian, it may appear yellowish or sallow in some lights and therefore rather cooler overall.

A similar narrow range of warmish colours is to be found in Asian skin; this may give a rather flat impression. However, you have only to look at Paul Gauguin's paintings of Polynesians to realize that there is plenty of room for invention in rendering such skin colours.

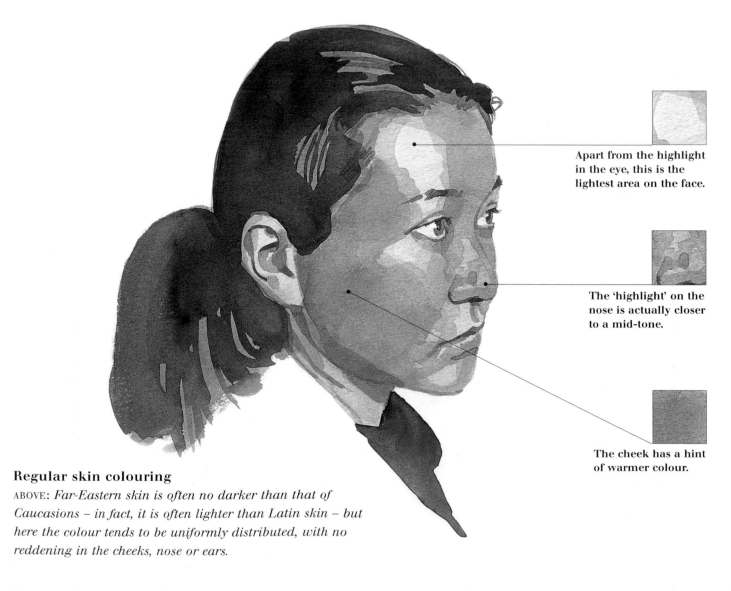

Apart from the highlight
in the eye, this is the
lightest area on the face.

The 'highlight' on the
nose is actually closer
to a mid-tone.

The cheek has a hint
of warmer colour.

Regular skin colouring
ABOVE: *Far-Eastern skin is often no darker than that of
Caucasions – in fact, it is often lighter than Latin skin – but
here the colour tends to be uniformly distributed, with no
reddening in the cheeks, nose or ears.*

Setting the colour temperature

LEFT: *This drawing of a student from Bombay was worked with pastel pencils on warm-coloured pastel paper, establishing the general colour temperature from the outset. Darker skin is generally accompanied by dark, often black, hair, in which the highlights are cool and sometimes quite noticeably blue (see pages 12–3).*

Warm shadows

ABOVE: *In this gouache sketch made in bright sunlight, even the shadow areas are warm. In different circumstances the shadows can reflect much cooler colours – the result depends on the colour temperature of the surroundings.*

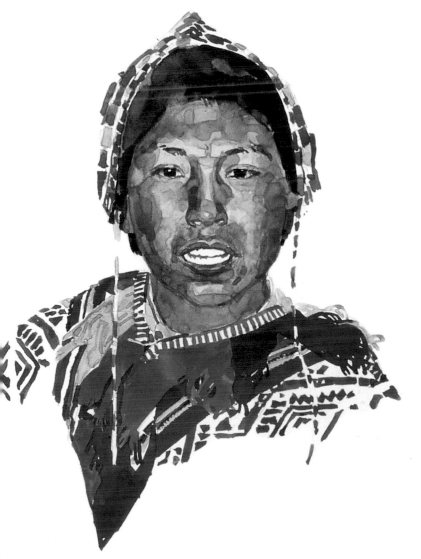

Brilliant colours

LEFT: *The dark, hot Indian reds and siennas of this strong South American face provide a wonderful contrast to the bright primary colours of the clothing and head-dress. The paint texture was created by using watercolour on a non-absorbent coated art board.*

39

Reflected light on dark skin

In terms of drawing or painting, the term 'dark skin' covers a wide range of pigmentation, from light mid-brown through to shiny blue-black. What is common to nearly all the shades of dark skin is the way in which the skin reflects light.

As WITH THE ALL-OVER tanned appearance of 'olive' or Latin skin colours, black skin tends to be too opaque to show much variation in colour temperature due to blood supply (although any skin colour can look ashen when drained of blood); however, areas of shadow and light may still reflect warm or cool colours to your eye. There are also seasonal changes: the pigmentation even of black skin changes in response to the amount of exposure to unfiltered sunlight.

Highlights occur where surfaces are very smooth or are rendered smooth by being covered by a film of liquid. All skin can reflect highlights, especially when wet, but the darker the skin the more clearly they will be seen. Therefore, although any colour of skin that is sweating will look very shiny and have highlights everywhere, a very black skin will have the most contrast between the highlight and the background, sometimes to the extent of overpowering other effects of light and shade.

Using contrasts

BELOW: *This head, drawn in densely packed crosshatching with a soft pencil, leaves the white of the paper to represent the highlights. It is lit from the right, but the highlights shine into the viewer's eye from points nearer to the centre.*

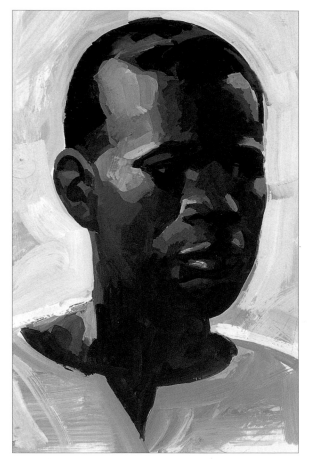

Highlights

ABOVE: *Look carefully at the colour of highlights, as they are rarely completely white: only on glass or pure white objects do they approach whiteness, and on any skin they always have a tinge of colour.*

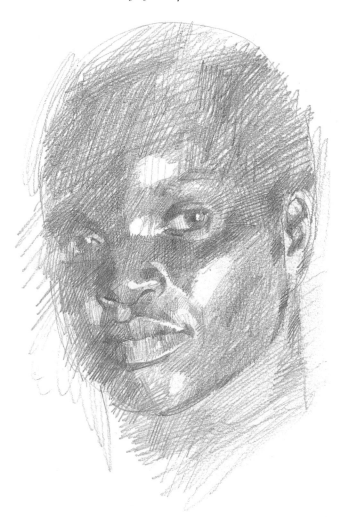

Practice Exercise: PAINTING REFLECTED LIGHT

When painting reflected light on a dark skin lit by a strong, direct source, be prepared to mix and use a surprisingly large number of colours if you want to portray the highlights accurately.

1 Start by setting down the overall tone of the frontal planes and the structure of the head – a fast-drying medium such as acrylics, used transparently, allows you to work relatively quickly. It is a good idea to put in marks that show where the pupils of the eyes are.

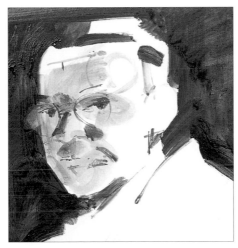

2 With the basic structure and the beginnings of tonality established, I then worked quickly to apply a dark background. This serves two purposes: to fix the shape of the head and to give a dark basis to work from when painting the skin colour and highlights.

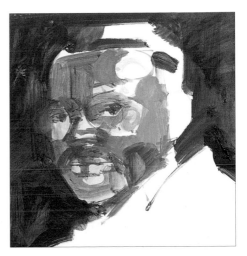

3 My next stage was to approximate the skin colour in the shadowed side of the face, now using opaque colours. The temples are cooler than the rest of the head, and you can start to see the shape of the skull. The white areas are a guide to shape, not to highlights.

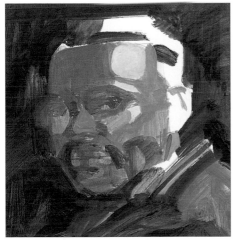

4 When you have got this far, you can work more confidently, but don't stop questioning – there is still room to amend while adding the first suggestions of reflected light on the skin. These light tones are opaque, while the darker ones still use transparent glazes to lower the tonal key for the shadow areas.

5 It is impossible to make final judgements about tone and colour until all the white patches have been covered. I added the hot colours for the ear and then used slightly opaque, cooler colours to distinguish the hair from the dark background. The reflections on the glasses and the warm colours for the facial details were the last touches.

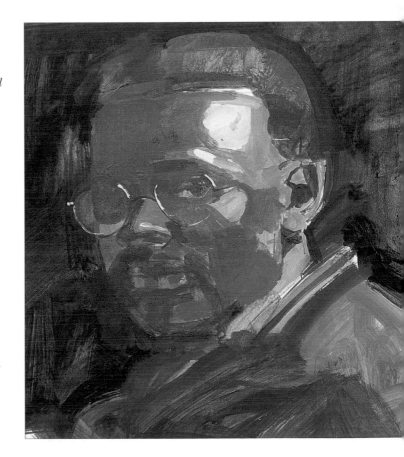

Hair colour

When dealing with heads of hair, you should look at hair as blocks of
form rather than as individual strands. These composite forms reveal
their colour – and, following that, their texture – by reflecting light in
various ways, according to the colour, shade and type of hair.

WITH STRAIGHT OR WAVY hair, the sheen will probably be reflected by quite clearly defined areas of highlight. Different shades of dark hair are almost indistinguishable except by reference to the colour of the highlights: dark auburn hair may reflect orange-red highlights, dark brown may have colder light- or mid-brown highlights, and really black hair almost invariably sports wonderful blue highlights.

Lighter hair transmits its colour by reference to both the shadow areas and the highlights; even blonde hair has surprisingly dark tones in some areas against which the highlights can shine. Look carefully at these lights – even the brightest are almost never pure white but have a tinge of colour that gives the clue to the exact overall colour and tone.

In the case of curly hair (see pages 26–7 for examples), the highlights are less clearly defined than is the case with straight or wavy hair; they tend to be fragmented, as each curl has its own pattern of highlights and relative dark areas.

The colour of highlights

In the three drawings here you can see that the background tone of each head of hair is very similar – it is only the different highlight colours that tell the full story.

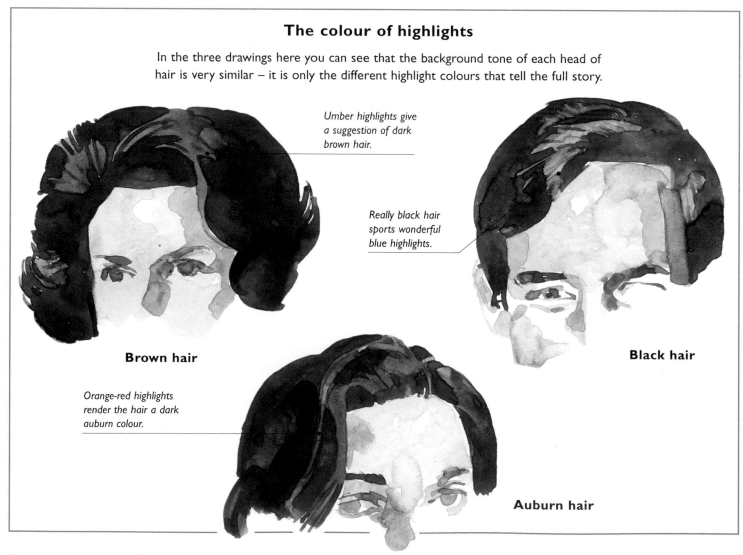

Umber highlights give a suggestion of dark brown hair.

Really black hair sports wonderful blue highlights.

Brown hair

Orange-red highlights render the hair a dark auburn colour.

Black hair

Auburn hair

Smooth and dark

LEFT: *Straight dark hair pulled back and secured tight to the head has the appearance of a helmet, the shiny surface showing only one smooth bar of highlight. Where it falls free at the back it can be rendered with bold swathes of individual lights.*

Wet blonde hair

RIGHT: *Although blonde hair has a lighter background colour than dark hair, it is not uniformly so; in places there may be surprisingly dark passages. The highlights have some colour, too, even when the hair is wet and shiny, as here.*

Practice Exercise: DRAWING HAIR

To get the most out of a study of hair, choose a pose where the maximum amount can be drawn.

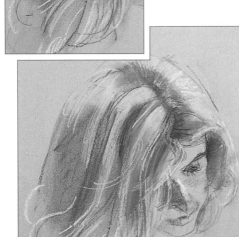

1 *Where the main area of a drawing will be taken up by hair, it is a good idea to start by establishing the angle and shape of the features; here, there is just a suggestion of the jawline. I made just a few light pastel marks to indicate where the hair falls over the face.*

2 *Start the broad, definite strokes that show the direction and mass of hair from the parting, as this reminds you of the cranium beneath. With pastels, apply the darker tones first. I used three fingers to blend in the hatched strokes, among them the 'flick' on the far side.*

3 *The lighter strokes indicate the layers and different directions in which the hair falls. There is a kind of 'double shine' at the parting for which I used a little blue pastel pencil. Inset: Use the outer parts and strands of hair to suggest the volume of the whole.*

Bringing it all together

As discussed on page 38, tanned and Asian skin is less transparent and more uniform in colour than fair Caucasian skin; there are no obvious colour temperature changes in the face, and warm tones predominate. The sitter here is of Indian origin, with dramatic colouring and classic features – a strong nose and cheekbones, and almost black, almond-shape eyes.

In the studio, both lights and shadows appeared warm, so to provide some colour temperature contrast, I chose this bright pink top – although red and pink are at the warm end of the spectrum, this is devoid of any yellow component and can be considered quite cool.

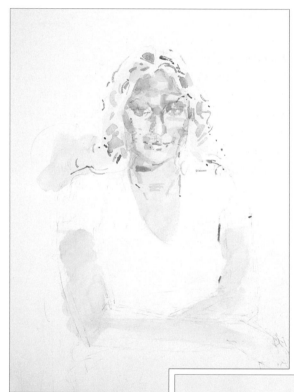

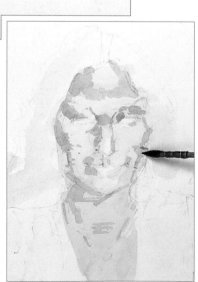

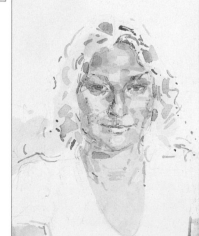

1 *Apply very light washes on the skin to establish the positions of the head and arms. Even if you are using a preliminary drawing, you are creating the first stage, not just colouring in.*
Inset: *I used only warm colours when building up the main forms, and made little dabs with the brush.*

2 *Add a light wash to indicate the position of the iris – this can be changed if necessary – and add the direction of the waves of hair using blue washes as notes.*
Inset: *I modified the shape of the eyelids and fixed the centre of the pupils before applying slightly warmer washes to the nose and mouth.*

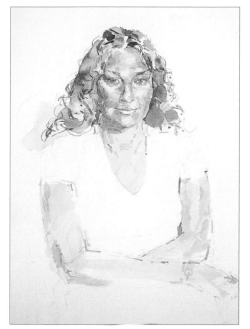

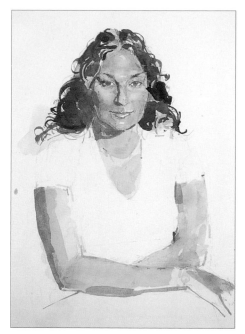

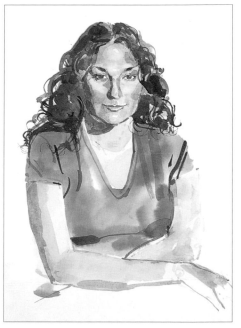

3 *With the proportions of the face established, look for the shapes of the hair, both covering the face and coming out from the head. Use short brushstrokes to catch the movement of the hair, then add bold, dark washes for the shadow side of the face.*

4 *Starting in the shadow areas, you can now strengthen the tones overall – but only when satisfied that everything is in the right place. While waiting for the washes to dry, I added darker lines to the eyelids and eyes. Any washes on the hair must let the movement show.*

5 *As you add more intense, hot colours, like the pinky-red of the lips, keep applying them in washes, otherwise they can look too dry. I used a very strong, brilliant moss rose stain for the shirt, which left no room for errors, especially on the folds.*

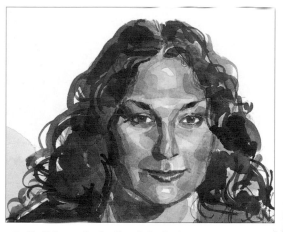

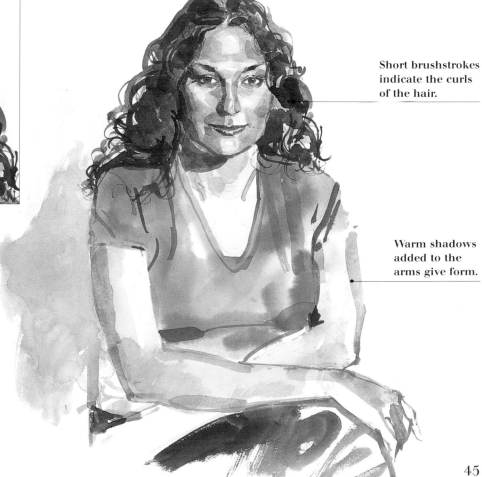

6 *Build up the bulk of the hair and the farthest strands and curls. Strengthen the folds and creases and the overall colour on the shirt, then add the shadows on the arms to establish their form and set a context for the figure. Inset: Continue to apply the facial details – note the red on the cheekbones – so that the sitter's individuality emerges.*

Short brushstrokes indicate the curls of the hair.

Warm shadows added to the arms give form.

45

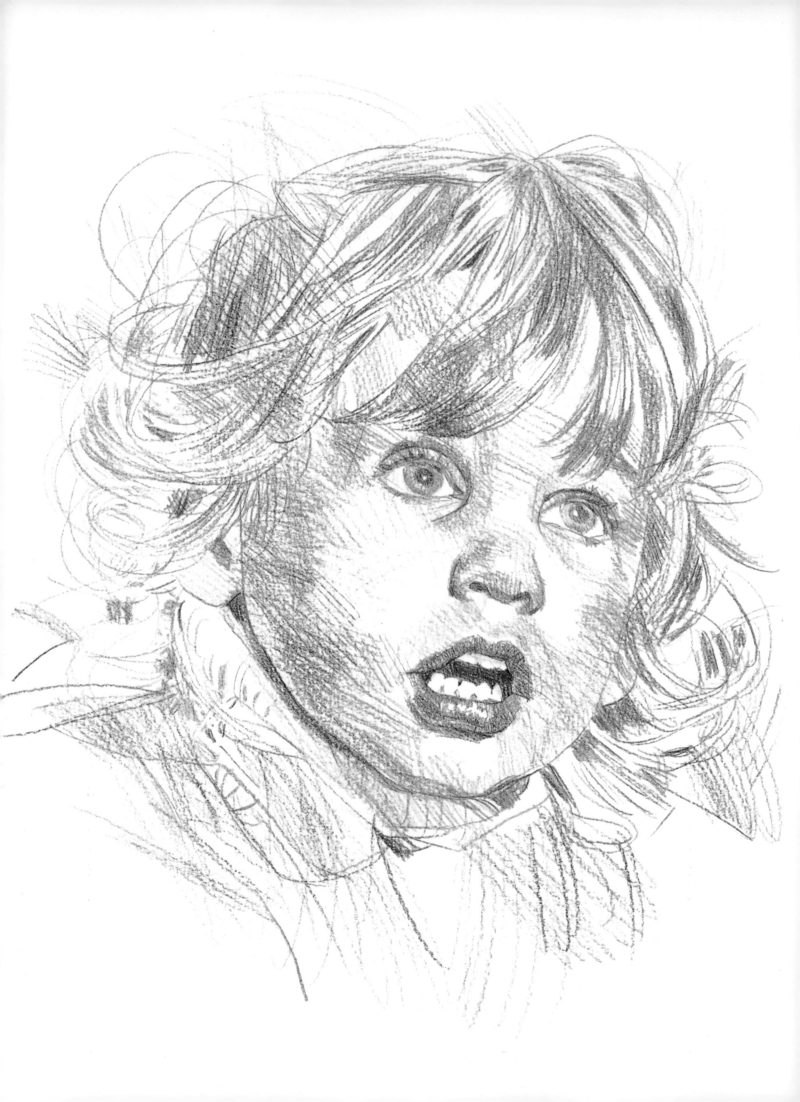

Character and Expression

Bringing a portrait or study of a person
to life is more than simply a matter of getting
the physical details right – it is about being able
to depict their personality. Many factors
contribute to character, not all of them facial,
and learning how to catch the more extreme
or fleeting expressions and indications of
individuality adds another vital string
to the artist's bow.

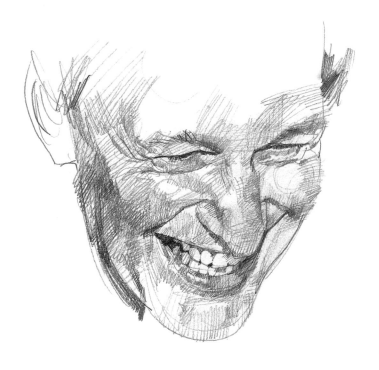

Facial expressions

The skull has only one moving part, the lower jaw, operated by a couple of powerful muscle groups. The other superficial muscles of the face are attached in the same way, but interact to move the tissues of the face that create an amazing array of facial expressions.

SOME FACIAL MUSCLE movements facilitate action, narrowing the eyes against bright light and opening the mouth for food or speech, for example, but above all they enable the face to pull itself into an astonishing array of expressions. Some of these expressions are conscious reinforcements of the spoken word while others are intended to send messages on their own, and there are others that are quite involuntary. All of us are adept at reading these expressions, even those that are not made consciously. The smallest muscular movement can be readily detected by an observer and can make an enormous difference to the perceived expression.

Flexing the facial muscles, whether voluntarily or involuntarily, produces bunching and creasing of the skin, and with constant repetition some of the creases and folds become permanent. Frown and laugh lines stay and deepen over time, telling us a great deal about the person's character and habitual temperament.

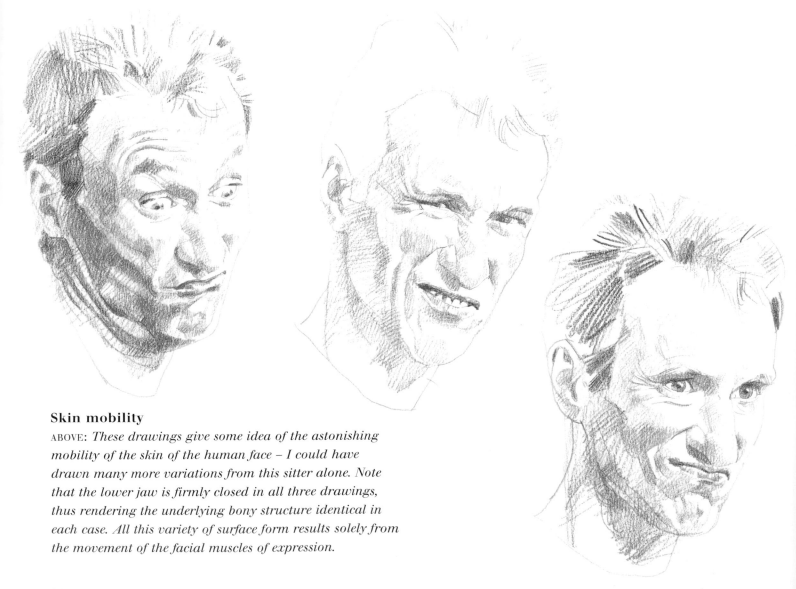

Skin mobility
ABOVE: *These drawings give some idea of the astonishing mobility of the skin of the human face – I could have drawn many more variations from this sitter alone. Note that the lower jaw is firmly closed in all three drawings, thus rendering the underlying bony structure identical in each case. All this variety of surface form results solely from the movement of the facial muscles of expression.*

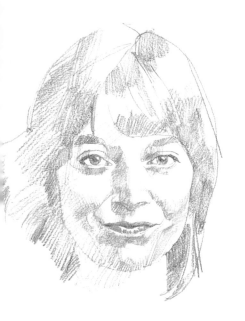
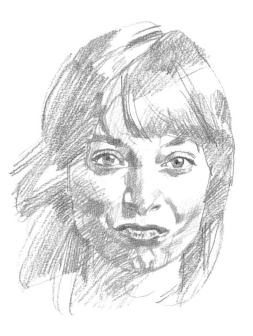
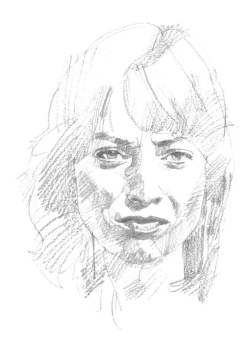

Progressing expressions

ABOVE: *Here, I asked the sitter to increase the severity of her expression, initially just pursing her lips slightly. For the second drawing she pushed her lips forward a little more and clenched her chin. For the third expression the eyes have been included in the action, narrowing slightly and furrowing between the brows.*

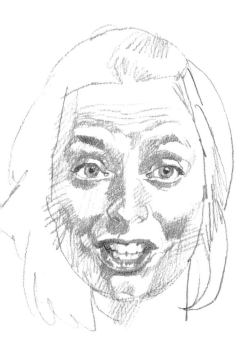
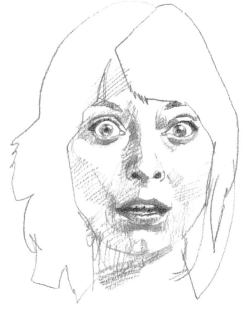
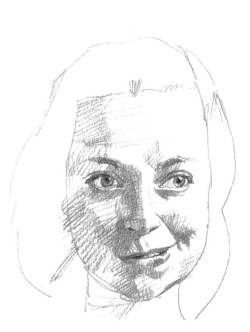

Working with a sitter

ABOVE: *If you can find someone to pull faces for you – perhaps yourself – just watch what happens when the eyebrows are raised or pulled together in a frown in combination with wide open or squinting eyes. Experiment with the pulls that can be exerted on the mouth by various clenching of the muscles of the cheeks and chin. Take photographs as the expressions appear. Be alert also for expressions that involve asymmetrical muscle pulls.*

Sketching from photographs

Drawing from life is always best – there is no substitute for the sense of three-dimensional solidity that you get with two-eyed, stereoscopic vision. However, a problem can occur when the subject is moving too quickly or when expressions are changing too rapidly for you to be able to draw them.

HOWEVER GOOD YOUR visual memory, it is only rarely that much objective information can be retained in the mind's eye. Here, photography can come to the rescue, as fleeting expressions, momentary glances and turns of the head (as well as red-eye and blinking) are all captured by the speed of electronic flash illumination.

A degree of guilt is sometimes attached to drawing from photographs – it is thought in some way to be cheating. My feeling is that although a photograph stays still and is even traceable, it does not have real solidity, only the illusion of it rendered by light and shade. So it is in some ways more difficult to make a good drawing from a photograph, where you may be tempted merely to copy, than it is to draw from life, where you must interpret freshly each time.

Having said that, much can be learned from photographic images. Making rapid sketches from the television is good practice, and still and slow-motion frames of a video recording can give you a little extra time for more complete studies.

Stopping the action
BELOW: *Freeze frames from television or film are frequently blurred but can still provide useful reference and may have an extra feeling of immediacy and movement.*

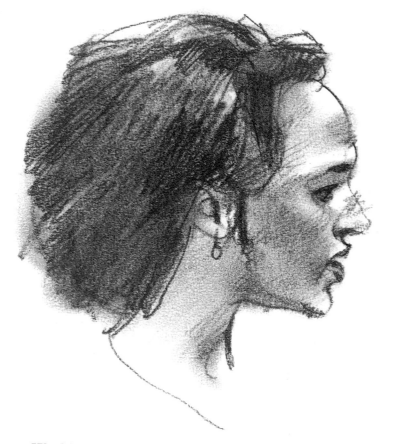

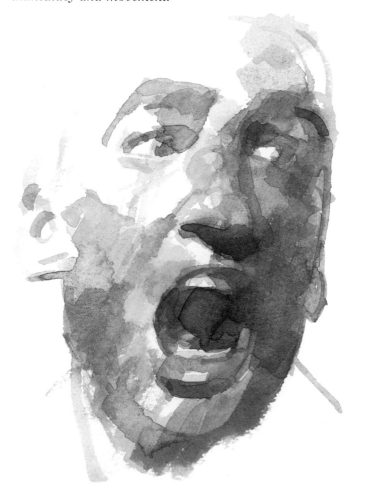

Working quickly
ABOVE: *Conté stick is a useful medium when speed is of the essence – large areas of tone can be quickly applied, a relatively precise line can be made by snapping the stick as needed, and lighter tones can be rubbed with the finger.*

Mouth shapes

LEFT: *The mouth is capable of assuming some extraordinary shapes in order to produce certain sounds. This is one of the more extreme ones associated with normal speech, that is, without the wide-open mouth assumed when shouting.*

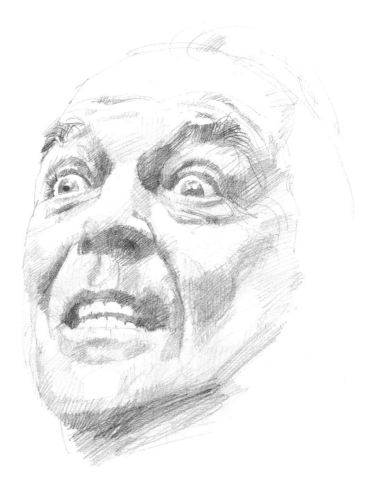

Surprise

ABOVE: *Eyes showing white above the iris are usually associated with laughter (try covering up the bottom half of the face), but the addition of a non-smiling, but teeth-revealing mouth has changed the expression to one of surprised apprehension.*

On the alert

LEFT: *Speech may or may not be involved in this rather wary but alert expression. Note the watchful eyes and slightly flared nostrils.*

Sketching children

You really cannot expect toddlers to stay still while you draw them. They may be wonderful subjects, but they are usually hopeless models. Babies are a little easier: they are fairly still while feeding, and they do sleep a lot – consequently, this is the best time to try to make a finished study from life.

WHEN DRAWING SLEEPING children, there is always the chance that you will get lucky, as I did when drawing my daughter (below), and have a glimpse of open eyes before the baby awakes fully. Otherwise you will have to resort to sketching what you can as children move about and play. Spontaneous sketches that are full of vitality may result, but it would be dishonest of me to say that it is easy and you may well end up with only fragments. It becomes much easier when children are old enough to become engrossed in something – a book, say, or television.

Of course there are always photographs, but try not to use them as your sole reference source. However sketchy and incomplete your drawings from life may be, the direct observation will have given you insight which will help you to interpret your photographs.

Choosing a medium

Pencil has certain advantages as a medium for on-the-spot sketching of sleeping children. Its lightness and mobility enable you to take advantage of what fleeting opportunities there are, and it is relatively clean – charcoal, pastels, gouache and oil paints are not likely to be popular near the baby's cot.

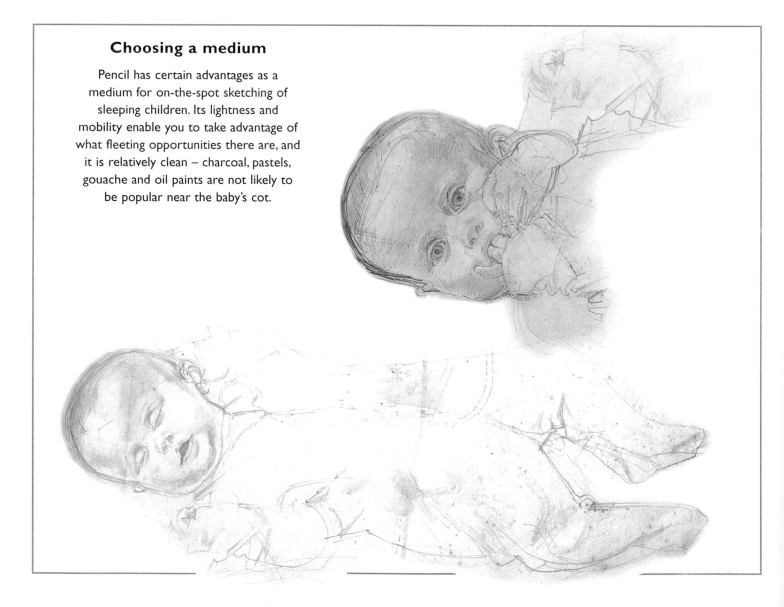

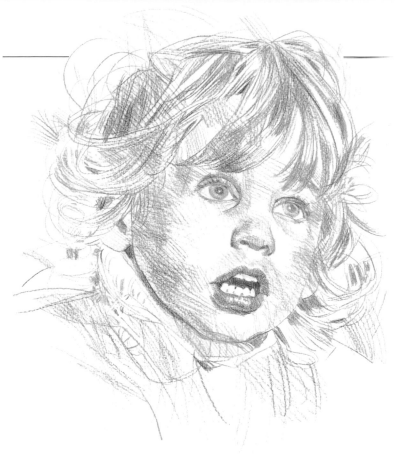

Catching the moment

BELOW: *This expression has an immediacy that the child would only maintain for a few seconds – the perfect situation for using photographs for speed.*

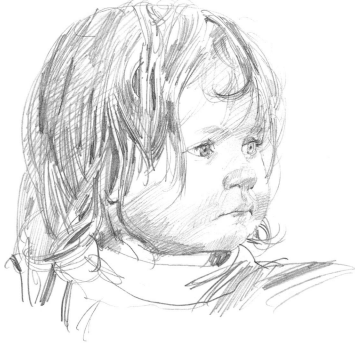

Working from photographs

ABOVE: *Photographs were used for both this drawing and the one on the right. The open-mouthed expression above could only be caught by the camera. Drawing from a photograph, the most important thing to remember is that there is no point whatever in making an exact replica of it – search for the form as you do when drawing from life.*

Finding the pose

RIGHT: *Children (and adults for that matter) often adopt and hold interesting poses while watching television. Always be alert to take advantage of these opportunities. Very quick sketches can be made by making a soft pastel generalization of the pose and drawing in the details with pastel pencils.*

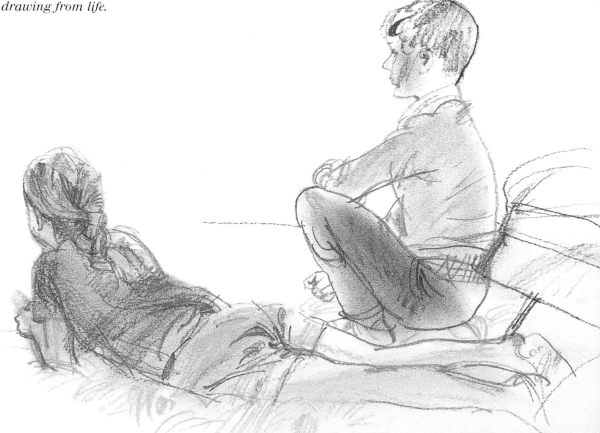

The smile

*The conventional representation of a smile is a mouth curving
upwards at the corners. However, to draw a smile realistically
you need to be aware of the subtle changes that occur across
the whole face – the eyes and cheeks in particular.*

OBSERVE THE ENORMOUS RANGE of smiles and smiling
expressions that are possible, even from one
individual face. The clues to identifying a smile lie not
only in the mouth but in the cheeks and eyes. The
bunching of the cheek muscles acts to widen the mouth
and to push up the lower eyelids, narrowing the eyes. In
a really broad, open-mouthed laugh, the eyes may even
become narrow slits.

The combination of all these actions results in the smile.
The face is very flexible and creates a number of
expressions with very subtle differences. For example, a
widened mouth not reinforced by narrowed, 'smiling'
eyes can look more like a grimace of pain.

It is very difficult for a sitter to maintain a smile for any
length of time without it looking unnatural. Take
photographs to use as reference.

The difference between a smile and a frown

The drawings below illustrate how you can convey two different moods with very subtle changes in
the face. In both drawings, the mouth is essentially the same shape. In the left-hand drawing the eyes
are narrowed in the 'smiling' mode. In the right-hand drawing, the brows are pulled down at their
inner ends, covering the upper eyelids and allowing the lower lids to drop – creating a frown.

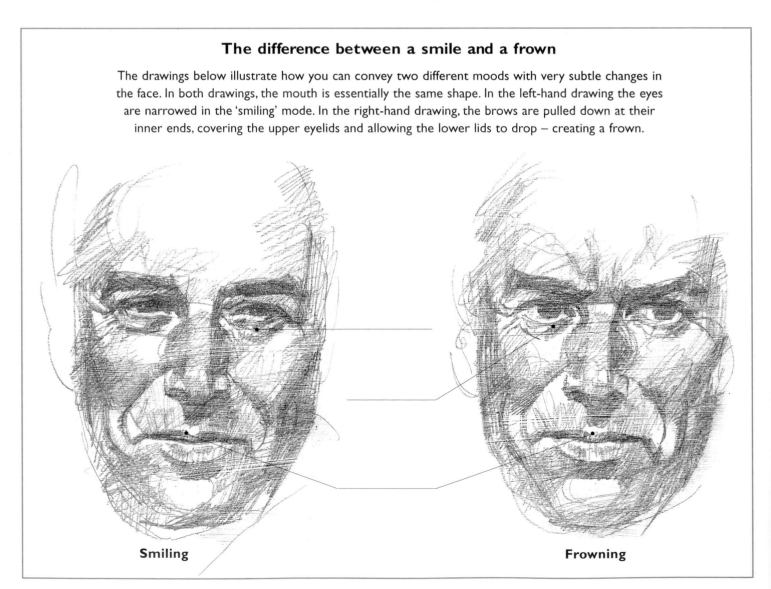

Smiling **Frowning**

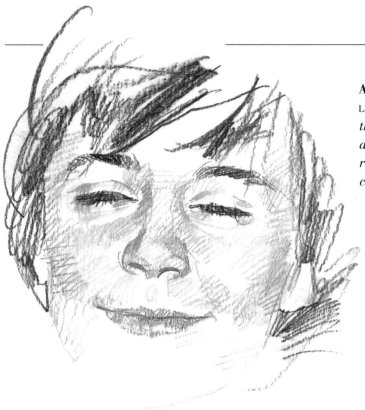

A contented expression

LEFT: *In this variation on the closed-mouth smile, the mouth is only slightly widened and the eyes are completely closed by lowering the upper eyelids, rather than bunching the cheeks. The result is a contented, peaceful expression.*

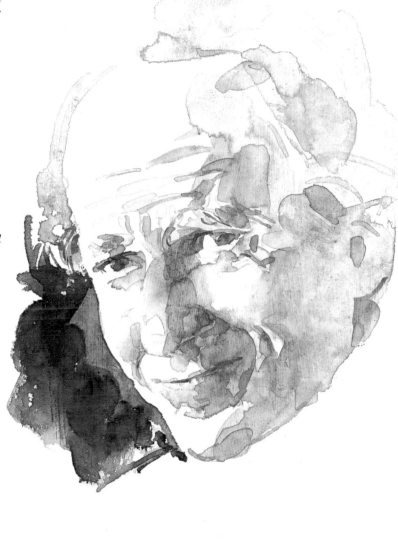

A quizzical smile

RIGHT: *Although this expression involves the widened mouth, tensed cheek muscles and narrowed eyes typical of a smile, it has resulted in a more quizzical, interrogative look. This may be due to the furrowed brow and the slight pursing of the lips.*

From a low viewpoint

LEFT: *The perspective of a low viewpoint can mean that even a smiling mouth will be seen as a downward curve. Yet with the help of the bunched cheeks and the slightly raised lower eyelids, there is no difficulty in recognizing the expression as a smile.*

Open-mouth smiles

As a smile broadens and laughter approaches, the lips part and reveal the teeth. It is a spontaneous expression of pleasure or amusement and is intrinsically a reaction to stimuli. It is, however, too much to ask for a full open-mouth smile or laugh to be held for a portrait.

STRONG CLENCHING OF the facial muscles is required for a wide smile – remember how your face aches after a prolonged bout of uproarious laughter – and it looks false if maintained too long without stimuli. A good move is to study photographs to discover just what is going on in the fully open-mouth smile.

A common feature of all wide smiles is the revealing of the upper teeth and a varying amount of the upper gums. The lower teeth are often visible too, but only the teeth, sometimes only the tops of the teeth, and almost never the gums. (Fully baring the lower teeth is characteristic of completely different expressions, of aggression, fear and anger.) Do not forget to look at what happens to the eyes: as the cheek muscles bunch up and pull the mouth wide, they also push up the lower eyelids, narrowing and sometimes completely closing the eyes.

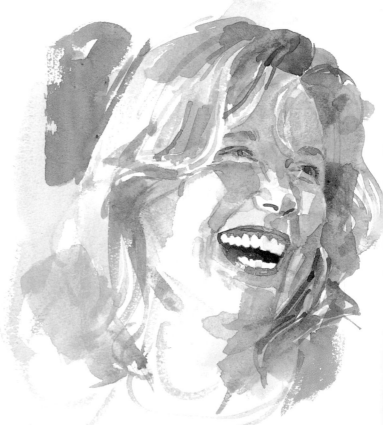

Teeth and gums

The scalloped shape of the gums very effectively suggests the shapes of the individual teeth: reinforce this by defining the lower, biting edge of the teeth, further lines to show the edges of the teeth are then almost unnecessary – and in any case should be very subtle.

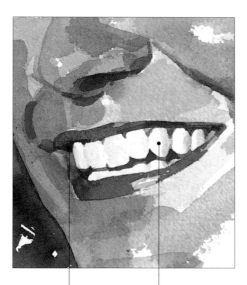

The corners of the mouth are dark, hot reds – not black.

Use careful (not too dark) shading to show the curving on the teeth.

The mouth interior

ABOVE: *A full laughing expression is produced by the cheek muscles pulling strongly outwards and the jaw lowering to open the mouth further. The view into the interior of the mouth is often rendered as dark brown, even black, but a more realistic impression can be made using hot red, orange-based shades.*

Almost-closed eyes

BELOW: *The strong upward and outward pull on the outer mouth edges by the bunched cheek muscles has virtually closed the eyes. This high eye-level view shows the arced shape of the palate very clearly.*

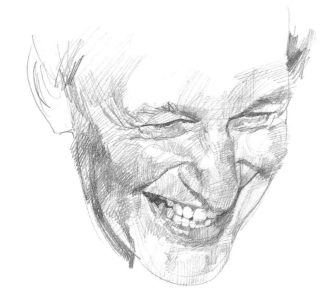

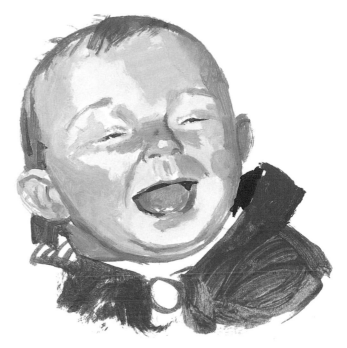

Smiling baby

ABOVE: *Although this baby has no visible teeth, his palate (which already contains his milk and adult teeth) imposes the same arced form under his lips, and his eyes are also nearly closed.*

Practice Exercise: OPEN-MOUTH SMILE

This angle of the head in this conté-crayon exercise concentrates on the direct effect that a smile makes on the cheeks and eyes, as well as the mouth itself.

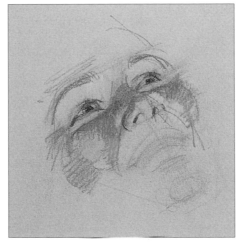

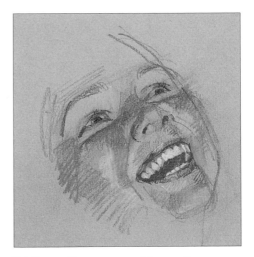

1 *Establish the frontal planes across the face, noting the closeness of the bottom of the eyes to the top of the clenched cheeks, caused by the low eye-level view. Note that the teeth follow the normal arc of the mouth area in the same facial plane.*

2 *Start to look for the form: as the cheeks bunch up towards the eyes, they push up the lower eyelid, 'cutting' into the pupil from below. From this angle, you can also see the thickness of the upper eyelid. The laugh lines, though not deep, define the edges of the cheeks.*

3 *Draw the upper and lower lips stretched taut across the arc of the teeth, then use hot colours to show the interior of the mouth and define the edges of the teeth. When the cheeks are this bunched, they tend to separate from the form of the chin.*

Extreme expressions

As with the practicalities of drawing a full smile, so it is with the really extreme expressions – rage, anguish, extreme effort – only more so: by their nature they are heartfelt, and so they cannot be held to order and must be studied by reference to photographs.

ALL EXTREME EXPRESSIONS have certain elements in common (baring of the lower teeth is often seen), but it is usually possible to distinguish one from the other. To start, look at the eyes. Bared lower teeth, combined with wide-open eyes and eyebrows pulled down in the centre in a severe frown, spell anger. The same mouth with eyes and brows sloping upwards to the middle gives an expression of anguish; and with a concentrated frown and eyes closed, you have an expression often seen on the face of athletes dipping for the tape or pushing a heavy weight. In a scream, staring eyes may combine with a wide-open mouth.

The point is that we immediately read the message in every expression but do not necessarily notice what the individual features are doing to make it. When you come to draw the expression, it is very interesting to analyze the combinations of active elements of the face – and the neck in some cases.

Changing expressions

A typically aggressive expression is produced by the lower lip being pulled outwards and downwards to bare the lower teeth as well as the top ones. Open eyes and a frowning brow reinforce the violent look. If the distorted mouth is combined with closed eyes, the expression becomes more one of pain or strain.

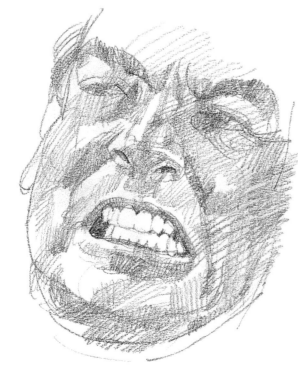

Aggression

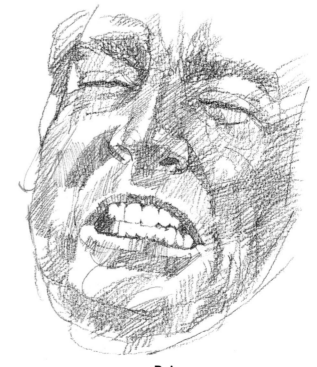

Pain

Using irregularities

RIGHT: *Look out for asymmetry in the features – here, the twisted mouth and one eye more open than the other lend authenticity to this extreme expression.*

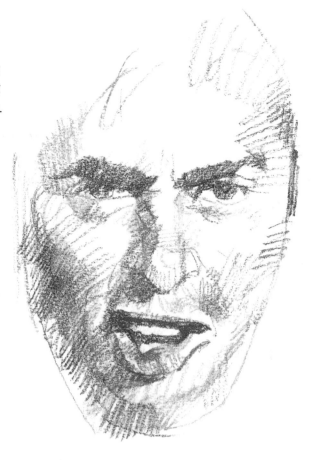

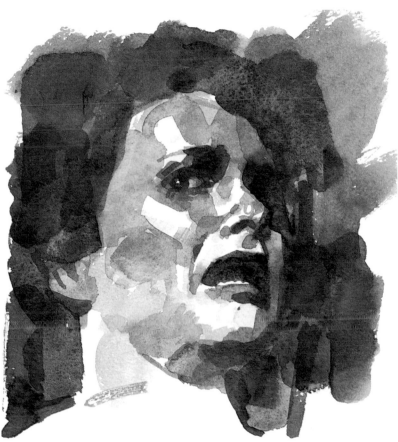

Fearful expression

ABOVE: *Here, the mouth is pulled down at the corners to a degree that not only exposes the lower teeth but also covers the top ones – a typical expression of fear or horror. The staring eyes add to the effect.*

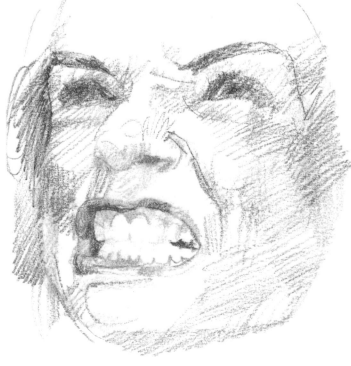

Attacking expression

RIGHT: *This expression is even more overtly aggressive than those on the opposite page, and is akin to the snarl of an aggressive dog. Note how the lips curl away from the teeth to show the top and bottom gums.*

Avoiding set expressions

A perennial problem for portraitists is a tendency for the sitter to lapse, after a while, into a somnolent state, complete with a glazed or bored expression. There are, however, a number of ways to alleviate this problem, and it is worth taking the time to discover which work for you best.

IF YOU CAN ACQUIRE THE knack of talking to a sitter while painting, conversation is a good way of keeping interest going, as is playing music. Fix a mirror so that the sitter can watch you working. Ask your sitter to choose a fixed point to look at when asked to, then only ask for a return to this position when you really need it – for instance, tell your sitter if you will not be painting his or her eyes for a while, so that he or she can close or rest them. Frequent rest periods are good for you both, and 15 minutes or so away from your work allows you to return to it with a fresh eye.

Ultimately, however, you may have to accept and deal with a certain amount of movement. If you ensure that the sitter returns to the set position often enough for you to make sure that the structure is right, you can observe the expressions as they come and go, decide on the one that is typical, and then put in something of it whenever it recurs during the sitting.

Changing the line of sight

After looking steadfastly in one direction for some time, your sitter may lapse into an almost trance-like state. Not only may the eyelids droop, but the muscles of the face may lose tone, thus depriving the face of all liveliness.

Here, just asking the sitter to change her line of sight towards the artist has made all the difference. The physical changes are quite subtle – her eyes are more open and focused, and there is a little rounding of the cheek at the corners of the mouth – but her expression is transformed into a far more lively one.

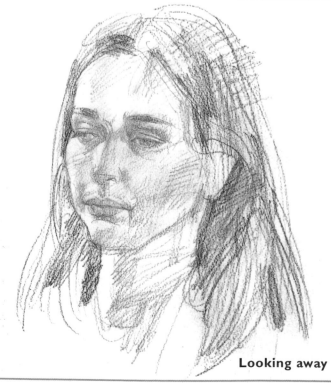

Looking away

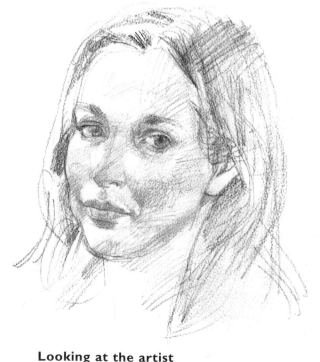

Looking at the artist

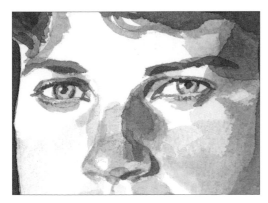 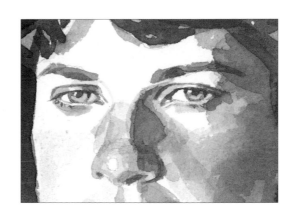

Imperceptible changes

ABOVE: *Here are two less extreme examples of the kind of difference that boredom can make to an expression. As you can see, in the picture on the right the eyelids have only drooped by a tiny amount, and yet the life has gone out of the face, compared to the picture on the left.*

Using a mirror

RIGHT: *A mirror carefully placed behind the artist can provide a view of the progressing painting, entertaining the sitter and helping to maintain an animated expression. Remember that such an arrangement will deflect the line of sight of the sitter to a point somewhat to one side of the painter: if you want your portrait to look straight out of the picture at the viewer, you will have to drag your sitter's attention from the painting and back to you from time to time.*

The hands

The hands are one of the most expressive parts of the body. We use them almost unconsciously when we talk and gestures can convey a wealth of moods and emotions – from fists shaken in anger to a relaxed wave or a loving caress.

HANDS HAVE A REPUTATION for being difficult things to draw. To do so successfully, the 'trick' is to think of the hand as a complete entity and to see how all the different parts interrelate within it. For instance, if you try to draw each finger individually, without being aware of how it is connected to the other fingers and to the back of the hand and wrist, the chances are that the finished hand will look clumsy and awkward. You will probably also be tempted to give too much importance to the individual elements, making the fingers too big in relation to the hand as a whole.

Similarly, the palm of the hand is often drawn as a flat shape to which the fingers are attached; in reality, it moves with the fingers and thumb and should be seen as a continuation of them, arching when the fingers are stretched and cupping when they curl.

The anatomy of the hand

On the back of the hand the bones and tendons can be clearly seen just below the skin; they largely dictate the surface form, unlike the palm, which is thickly padded with skin and fascia over a couple of muscle groups (see opposite, below right).

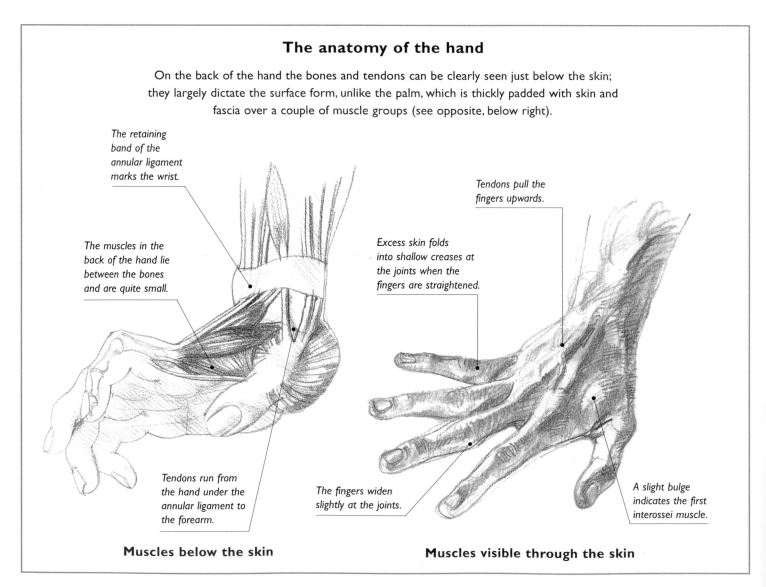

The retaining band of the annular ligament marks the wrist.

The muscles in the back of the hand lie between the bones and are quite small.

Tendons run from the hand under the annular ligament to the forearm.

Tendons pull the fingers upwards.

Excess skin folds into shallow creases at the joints when the fingers are straightened.

The fingers widen slightly at the joints.

A slight bulge indicates the first interossei muscle.

Muscles below the skin

Muscles visible through the skin

Alignments within the hand

RIGHT: *Although the shape of hands varies considerably from one person to another, there are some general principles that can give you a basis from which you can judge individual variations. Looking at your own hand in different positions is the best way to start analyzing the basic forms and structure.*

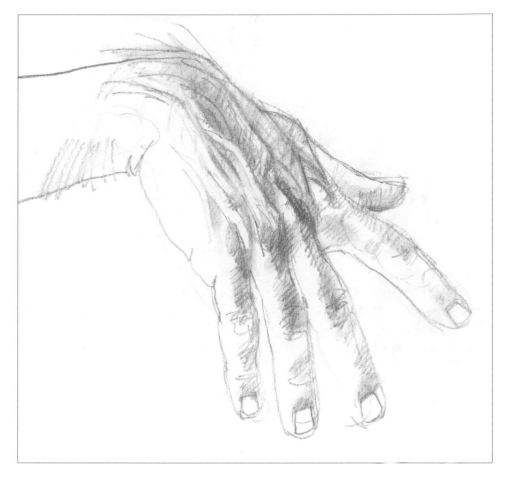

Upturned hand

BELOW: *The palm is quite different from the back of the hand, being heavily padded with thickened skin over a tough fascia and two quite prominent muscle groups, one at the base of the thumb and one from the wrist to the little finger. Look at how the permanent creases allow the fingers to bend and the cushioned surface of the palm to make a cupped form.*

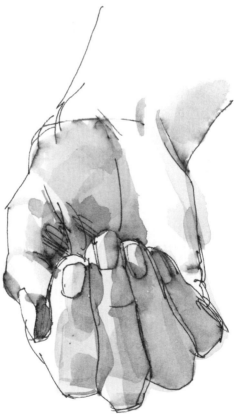

Conveying form with line and wash

ABOVE: *A hand in this position will hold water. The dark shadow of the base of the thumb suggests the concavity hidden by the fingers. Look carefully at the fingernails – the tip of the index finger here is visible above the nail while the extra bend of the other three conceals the tips.*

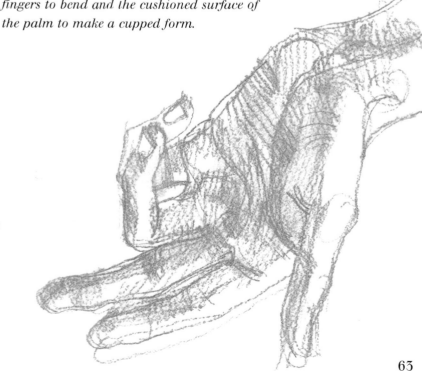

Expressive hands

After the features of the face, the hands are probably the most expressive part of the human body, and can be used to portray a great range of expressions and characterizations. Even a quick study of the portraits and figure drawings and paintings in any art gallery or museum will give you inspiration and suggestions about how to use hands to create the maximum impact. And if you can, repeat the exercise mentioned on page 14 and spend some time drawing hands from sculptures.

Capturing movement is a separate question and is not covered in this book, except to suggest that sketching simple, repetitive and limited movements of the hands is a good way to start: sewing, playing a musical instrument, writing with a pen, cutting bread or stirring a cup of coffee are all possible subjects.

Making generalizations about hands and character is tempting but not a successful approach, so look for variations in shape and size whenever you draw.

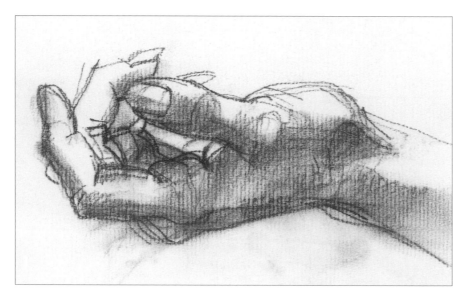

Relaxed hand

LEFT: *This side-on pose is interesting for the way in which it shows how the fingers and thumb work in opposition to each other: the thumbnail can be seen in its entirety, while the remaining fingernails are only partially visible as they are turned away from the viewer.*

Clenched fist

ABOVE: *Rather than drawing each finger individually, concentrate on the overall shape of the fist – a rough cube. Note how the knuckles form a hard, undulating ridge.*

Cupped hands

ABOVE: *When you are drawing hands cupped around an object, as here, think of the shape they are holding as well as that of the hands themselves. Here, the whole drawing is centred around the ellipse of the coffee cup.*

Two hands

RIGHT: *When hands are closely linked, it is better to think of them as one composite form. Search out linking shapes such as the curve that could be drawn here through the knuckles of the left hand, continuing along the top edge of the right hand. There is another curve linking the tip of the middle finger of the left hand, through the right hand knuckles to the first joint of the left thumb. (Note that I am speaking of the left and right as we see it, rather than the true left and right hands.)*

Practice Exercise: DRAWING HANDS

The pose for this exercise involves two views of hands: one foreshortened from the front, and one from the side, palm up.

1 *Before you start to use the pen, apply a light wash to establish the shapes and proportions.*
Inset: *Having set the basic forms, use details such as fingernails to define the position of the fingers and their relationship to the whole.*

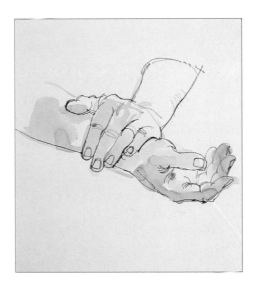

2 *Within the new frame-work of the pen lines, you can now add more tone with darker washes. At the same time, check the outlines and strengthen them once you are happy that they are accurate.*

3 *Continue to apply washes to show the contours of the hands and forearms; while adding dark tones, use the lighter ones to indicate the fall of light and the form of the fingers. The darkest tones indicate the cast shadows on the lower hand.*

The knuckle lines are reinforced by washes over the ink lines.

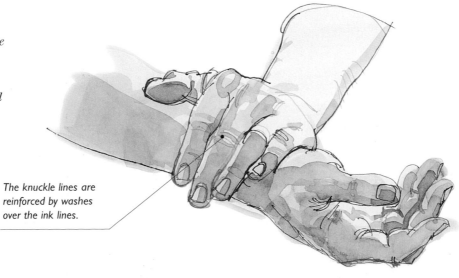

Character lines

Facial expressions that become habitual eventually create tell-tale folds and creases in the skin; these persist even when the emotions that caused them are not actually present. Such lines reveal not only past expressions and emotions, but, by inference, also hint at the experiences that gave rise to them.

IT IS PROBABLY TOO MUCH to ask that you should be able to interpret all the messages hidden in a mature face, but you should certainly try to find the prevalent patterns made by these superficial folds and creases without sacrificing the basic bone structure beneath.

It is very easy to overdo these patterns by rendering each crease as though it were a dark line tattooed on the skin – looked at more closely, a facial 'line' can be seen to be merely a dip, or ditch, in the continuous skin surface, not a major change in the form.

It may be that your subject would prefer that these lines of character were omitted from the drawing altogether – in a commissioned portrait it is probably advisable to tread carefully – but if they are judicially treated, with no overemphasis, they will help to contribute to the likeness and should not cause offence.

Lines and creases

Creases in the skin, especially those in the forehead, are interruptions in an otherwise continuous form. Although they are often depicted in line drawings by, not surprisingly, lines, in a continuous tone drawing you need to see them as they are – small ditches lit on one side, shaded on the other.

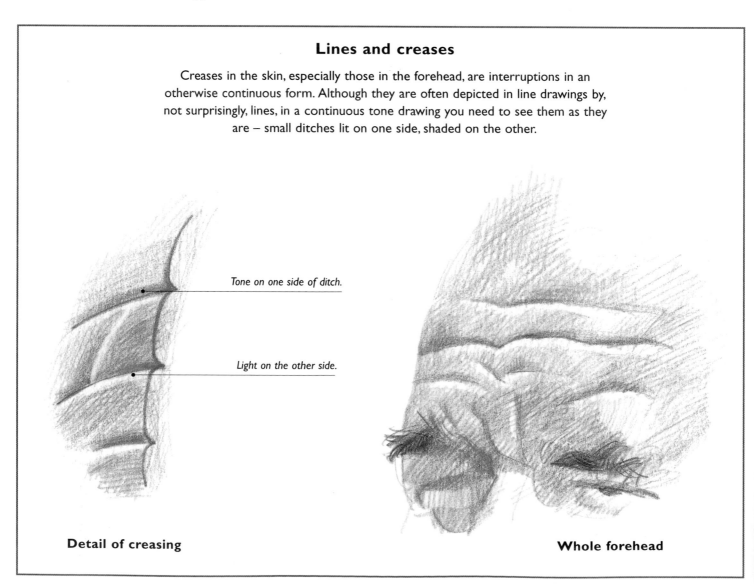

Tone on one side of ditch.

Light on the other side.

Detail of creasing

Whole forehead

Smile lines

RIGHT: *As you might guess, this is an habitual expression for this French producer of Muscadet wines. Most of the creases are formed by the bunching of his cheek muscles.*

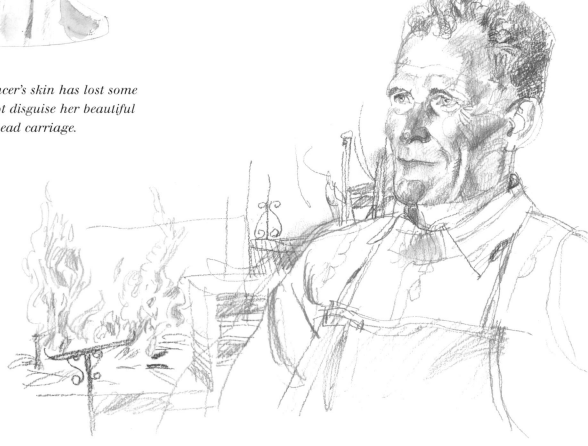

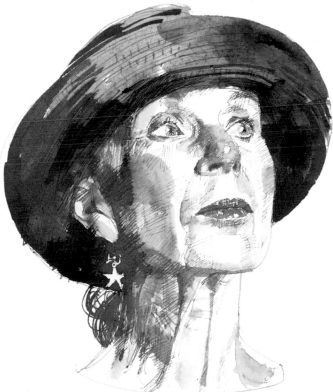

Elegant maturity

ABOVE: *The signs that this dancer's skin has lost some of its youthful elasticity do not disguise her beautiful bone structure and graceful head carriage.*

Outdoor work

RIGHT: *Tending his vines throughout the year in the Valley of the Loire has probably contributed to the deep creasing on this strong and characterful face.*

67

Older faces

As the skin of the face ages it changes in other ways than merely acquiring expression-induced folds and creases. The older face gives you so much more to work with, so much more scope for revealing the character and intelligence stored up in the facial record.

As PEOPLE AGE, IN SOME thin individuals the bones of the skull and face become increasingly more evident as the muscles atrophy. Heavier subjects may show less creasing – but more double chins. Hair may diminish on the head and flourish on the eyebrows or the nose, moles and 'liver spots' appear, and facial colour can become suffused with red hues or may fade to sallowness. With age skin tissue loses its youthful firmness and begins to sag under its own weight. Noses may become more fleshy and roseate or, in direct contrast, they may acquire a bony, beak-like appearance.

While it may be depressing to watch such changes in the mirror, the act of drawing these forms is very interesting and exciting. Probably the best paintings of an old man are the series of self-portraits by Rembrandt: in fact, nothing in words will tell you half as much as you will learn by looking closely at these splendid paintings and sketches, even in reproductions.

Variations in creases

LEFT: *Facial creases are depicted by interruptions in the skin tone rather than lines, but the big creases from the sides of the nose and the mouth are defined by deeper tones, almost thick lines.*

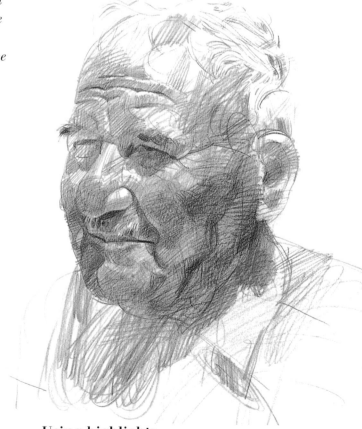

Using highlights

ABOVE: *For this sunlit head of an elderly man, almost the whole skin surface has been coloured, with only a few highlights left untouched by the wax pencils.*

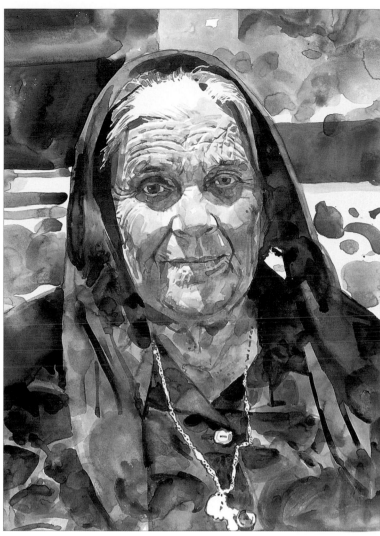

Light and shade

ABOVE: *The pattern of criss-cross creases in this lovely old Cypriot lady's face are exaggerated by – and probably caused by a lifetime under – strong sunlight. As before, areas of light and shade depict folds and creases rather than lines.*

Working with few clues

RIGHT: *Sunlight also plays a major part in this drawing of an elderly Cypriot goatherd. The strong fall of light from the right means that only the deepest facial lines, gathered over a lifetime, are detailed – the deep furrow from the nose to the chin, the forehead lines and the creases around the squinting eyes.*

69

Caricature

The priorities advocated for normal portraiture – the importance of correct assessment of the spaces between the features, the abstract pattern of the face to achieve a good likeness – are overturned for a caricature. In extreme examples, the features can have little relation with reality, becoming instead a set of accepted and recognized symbols.

THE INDIVIDUAL FEATURES are now the centre of attention: any particular quality that you perceive them to have can be exaggerated, perhaps to an extreme degree. The result is not a likeness in the true sense, but rather a set of symbols that remind you of the person depicted. If the subject possesses a very distinctive feature, a large nose or very bushy eyebrows for example, so much the better – there may be no need for much else besides these features drawn large to make a

recognizable caricature. In the absence of any unusual features, it can be a little more difficult: something may have to be made of a habitual facial expression or a typical item of dress or headgear.

In the end the only distinctive feature may be, after all, the arrangement of the facial features: perhaps they are close together in a large face or maybe there is something unusual in the spacing of the eyes or the prominence of the chin.

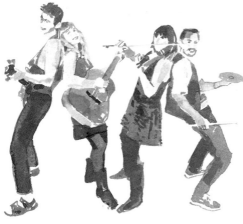

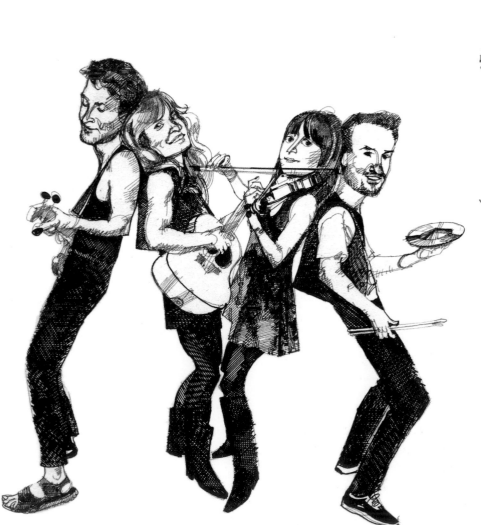

Large heads, small bodies
ABOVE AND LEFT: *A device often used in caricatures is this one, in which the caricatured heads are placed on diminutive bodies. The head enlargement, often more exaggerated than shown here, allows you to give the caricature action while concentrating attention on the heads and faces.*

 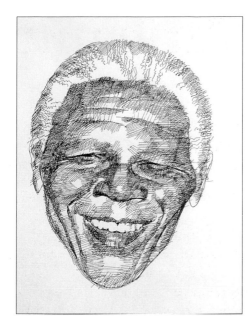

Exaggerating facial characteristics

ABOVE: *The first drawing here is, more or less, as the subject appears in reality. Then the nearly closed eyes, the big smiling mouth and the rather long chin were emphasized. Finally, the whole facial colour had to be achieved with hatching to show the halo of grey hair.*

Pushing the image

ABOVE: *As above, the first drawing is quite close to the head in real life. The low viewpoint emphasized the solidity and size of the lower jaw and chin, and the mouth was moved closer to the nose. In the final drawing, the eyes were made smaller, and the sweep of the hair and shading of the side of the head gave the caricature a sculptural, monumental quality.*

Bringing it all together

In going all out to capture a special character, you may find that you lose the form to some extent. This need not matter: many artists have sacrificed solidity in the interest of placing greater emphasis on the flat pattern. On the other hand, the form in the round may be the most important factor in the character that you are seeking, the flat pattern alone not telling the story. Once you have acquired the ability to render form convincingly, you then have the choice whether or not to make full use of it.

In this oil-paint portrait of my late father-in-law, the hat, the pose, the smile, the position of the hands, even the postcards on the wall all add up to make a picture that is typical of him – and him alone.

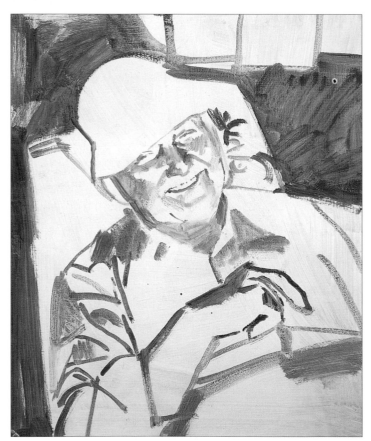

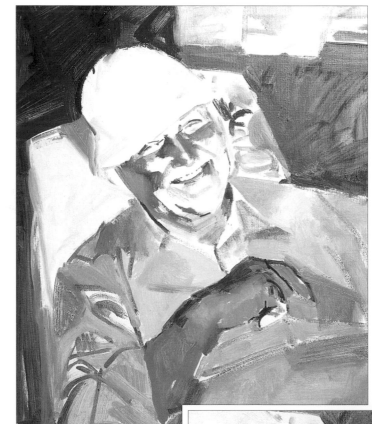

1 *Block in the main areas of the painting to establish the composition: on the figure, I concentrated on the facial area, the outline of the hand and the main lines on the shirt, in addition to suggesting the shape of the chair and the background. At this stage you do not have to apply the exact colours that will be in the final painting, but it is a good idea to show the warm tones in the middle of the face and the cooler ones at the side.*

2 *Once the white has been covered you can judge the tonality accurately, so block in the tones further and find the patterns. Note the scumbling on the shoulder.* **Inset:** *I applied hot colours on the face to bring out the character's cheery nature.*

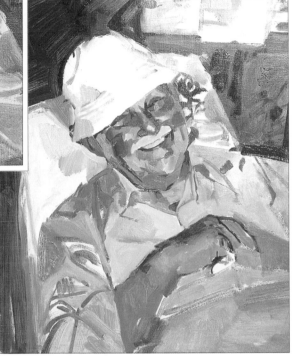

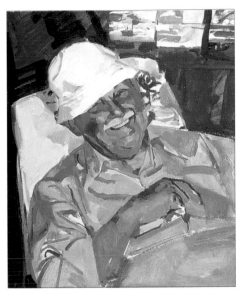

3 *Strengthen the tones of the background, and look for the contrasts on the head – here there is a yellow highlight on the lower part, and the moustache is pale cream, rather than white.* Inset: *Build up the face with ever warmer and cooler colours.*

4 *On a second look, the top lights and highlights on the face were cooler than the mid-lights or shadows, so I added a cool, clean pink to bring them out. I also included the detail of the postcards on the wall behind.*

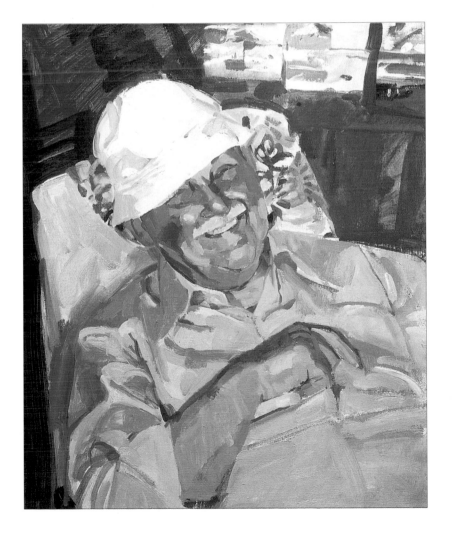

5 *Even at this late stage, continue to cover the white patches. The cool highlights on the face can be carried over onto the hand and arm, where they show up relatively light against the darker, shadowed upper edge. I added the lightest colours on the shirt and the creases – the most uniform tone is at the bottom of the picture, where the shirt is stretched over the stomach. I finished by adding details to the patterns on the cushion, and the very cool shadow areas on the hat.*

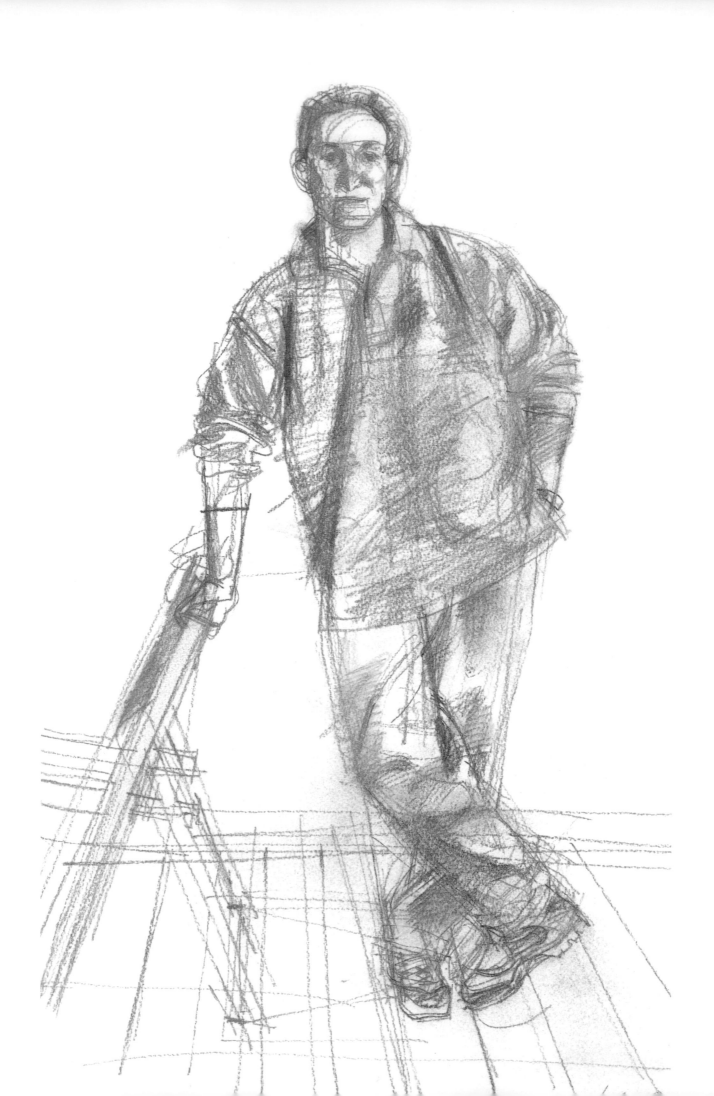

Poses

The human body can adapt itself into a
bewildering variety of different positions
and angles, both supported and unsupported.
Whether the pose is taut and full of tension or
relaxed and at ease, a successful portrayal is one
in which the underlying energy and solidity
of the figure are captured. You can also tell as
much about a person's character by their
body language and posture as by
a facial expression.

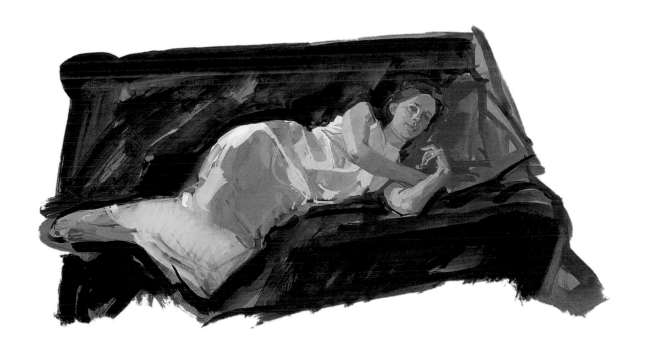

Simple anatomy

It is useful to know something of the underlying anatomy of the figure in order to understand poses. The skeleton, the bony structure upon which the whole body is supported, comes near to the skin surface at certain key points, which give you clues to what is going on in a pose.

THE KEY TO ANY POSE is the position of the backbone, the flexible column of bones (vertebrae) upon which the main weight of the body is hung. At one end of this is the shoulder girdle, from which the upper limbs depend, and at the other end the pelvic girdle (hips) allows attachment and free movement for the legs. Points on the edges of the pelvis show whether and how much the hips are tilted, while the outer ends of the collar bones reveal

any corresponding shoulder tilt. The vertebral column bends to adapt to these tilts and to hold the head in balance above them.

Muscles that pull on the skeleton tend to be fairly bulky and are responsible for the roundness of the limbs. Others activate the rib cage and hold in the internal organs of the abdomen; they are more like sheets, reflecting the form beneath.

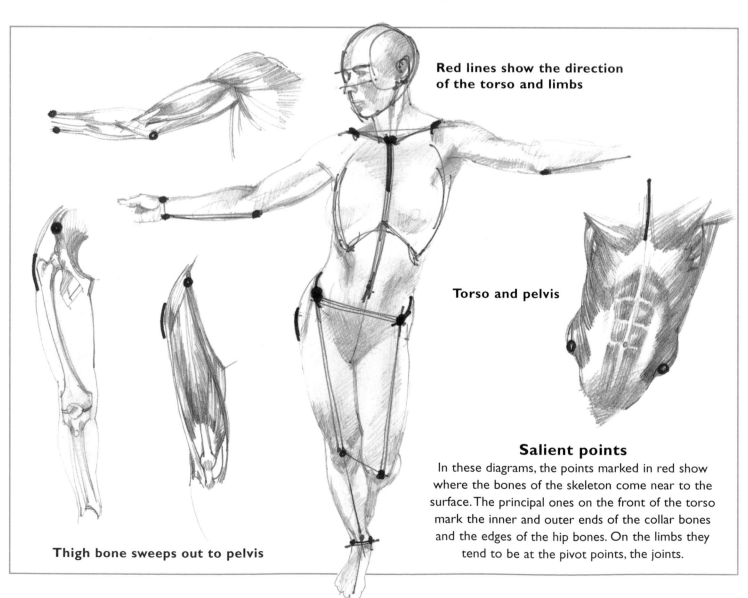

Red lines show the direction of the torso and limbs

Torso and pelvis

Salient points

In these diagrams, the points marked in red show where the bones of the skeleton come near to the surface. The principal ones on the front of the torso mark the inner and outer ends of the collar bones and the edges of the hip bones. On the limbs they tend to be at the pivot points, the joints.

Thigh bone sweeps out to pelvis

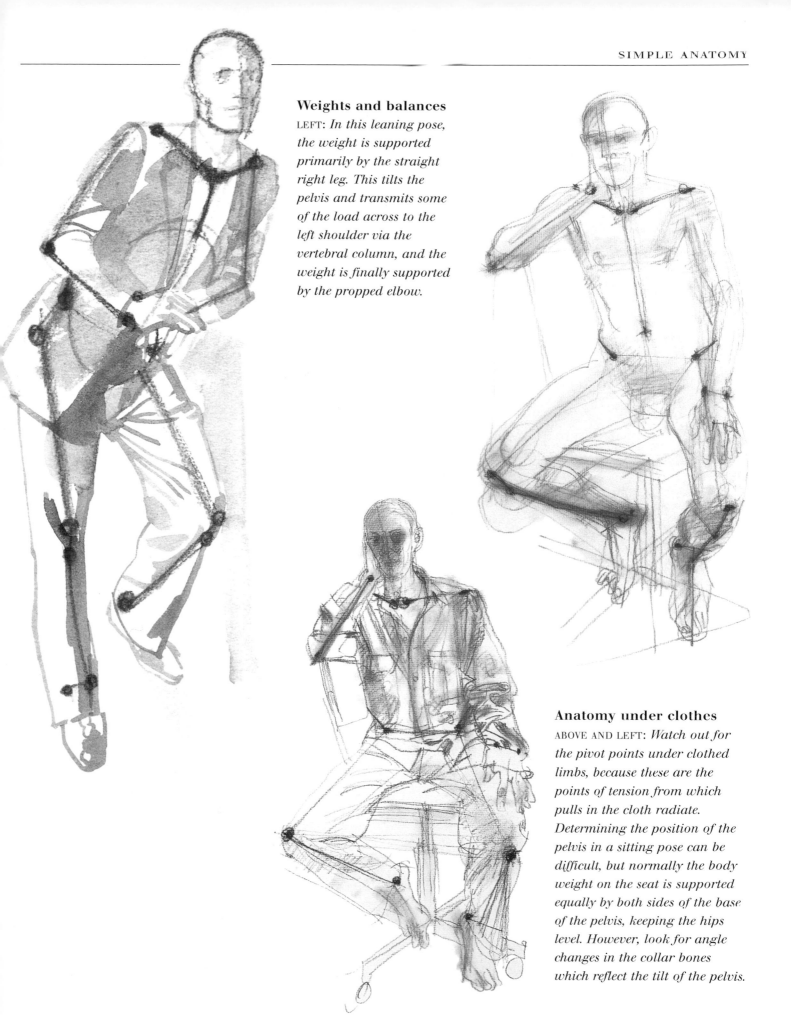

Weights and balances

LEFT: *In this leaning pose, the weight is supported primarily by the straight right leg. This tilts the pelvis and transmits some of the load across to the left shoulder via the vertebral column, and the weight is finally supported by the propped elbow.*

Anatomy under clothes

ABOVE AND LEFT: *Watch out for the pivot points under clothed limbs, because these are the points of tension from which pulls in the cloth radiate. Determining the position of the pelvis in a sitting pose can be difficult, but normally the body weight on the seat is supported equally by both sides of the base of the pelvis, keeping the hips level. However, look for angle changes in the collar bones which reflect the tilt of the pelvis.*

Posture and body language

*A great deal can be deduced and, in the same way, expressed by the way
that a person chooses to sit or stand. People often reveal their inner feelings
– security, insecurity, aggression, friendliness – by their posture. Such
unconscious signalling has come to be known as body language.*

POSTURE THAT HAS become habitual may be a reflection
of some overall character trait, but it is also possible
that it is due to having good or not-so-good natural
balance or muscle tone. More often than not, however,
within these limitations, unconscious gestures – leaning
forward or back, hugging oneself, opening arms and
shoulders expansively, for instance – say almost as
much as facial expressions.

Whenever you can, without causing offence, observe
how people dispose themselves, especially in groups of
two or more. Watch (and sketch) how they hold their
heads, what they do with their hands, whether their legs
are crossed or spread.

Someone sitting for you for the first time is quite likely
to feel unsure about the situation and may assume a stiff,
shut-in pose; alternatively, they may overcompensate
with flamboyant poses. For this reason, it is often
advisable mentally to write off the first drawing and wait
to see the more relaxed and natural position that the
sitter adopts during a rest period.

Interactive body language
BELOW: *These card-players show completely opposing body attitudes
– the man on the left is relaxed and literally laid-back, while his
companion/adversary is crouched forward, on edge, concentrating.*

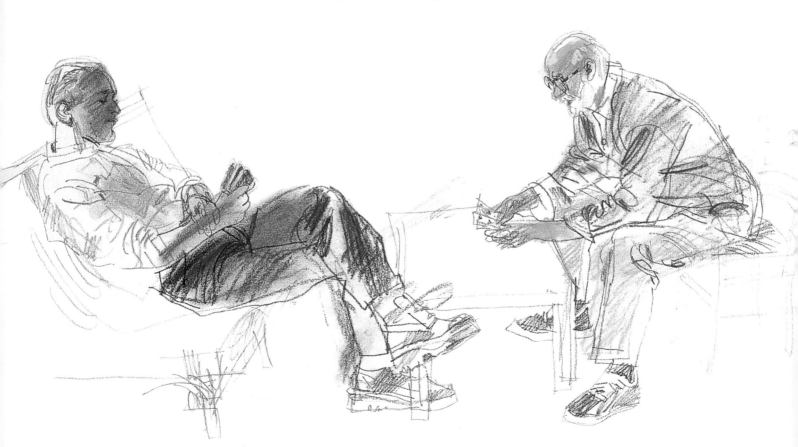

Keeping emotions in

BELOW: *Crossed legs, folded arms and a bent-over sitting stance: this has to be protective, introverted body language, especially if it is reinforced, as here, by cast-down eyes and an expressionless mouth.*

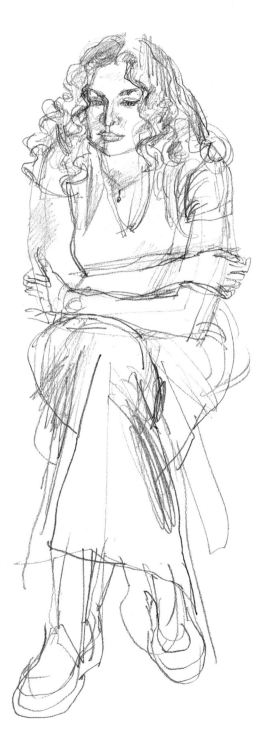

Letting emotions out

ABOVE: *A complete contrast! This is the same sitter, striking a pose that confronts and challenges – arms akimbo, hip thrust out, and direct gaze. Try out similar poses for yourself in the mirror or with a co-operative sitter.*

79

Clothes and fabrics

Fabric made into clothing most closely imitates skin when it is made of elastic fibres and can therefore be skin-tight while permitting movement. Usually, though, it is cut to fit the body loosely and is made from non-elastic fabric, which must accommodate itself to the movements of the limbs and torso as best it can.

LOOSELY DRAPED OVER a form, fabric is dragged floorwards by gravity. Where it is pressed against the form there are points of tension from which folds depend, and if it reaches the floor it folds upon itself. It is very useful to make studies of draped fabrics, to discover how they adapt to gravity and the forms they cover.

To fit the body, fabric is made into shapes that are, in general, tubular – sleeves and trouser legs are tubes that fit the limbs more or less closely, and the folds that appear in them are the result of tensions and slacknesses as the fabric is pulled and pushed by the forms beneath. These pulls may look random, but you will soon discover a sense and a characteristic pattern. As you understand what is happening to the cloth and the forces that are pulling on it, your drawing will be less dependent on exact reproduction of each fold – but more dynamic.

Studying fabrics

In addition to being instructive, making sketches and studies of the movement, texture and patterns of fabric and clothing can be a very enjoyable exercise – with or without a sitter.

Tension and looseness

BELOW: *An arm bent in a sleeve pushes against the fabric at the elbow, producing pulled folds of tension, while at the inside of the bend, excess fabric is forced to fold loosely on itself.*

Draped fabric

ABOVE: *Gravity tugs fabric downwards in long sweeping curves, from the line of stress of the chair back to the floor, where it concertinas up the excess material.*

Patterns

ABOVE: *If the distortions of simple patterns as they meander over clothing are carefully observed and drawn, they can describe the form with very little assistance from light and shade. Stripes are ideal for this.*

Practice Exercise: FABRIC FOLDS

When making a drawing to capture the movement and folds of clothing, choose a 'fast' medium – charcoal, oil bars or, as here, pastels and pastel pencils – that allows you to set down observations quickly.

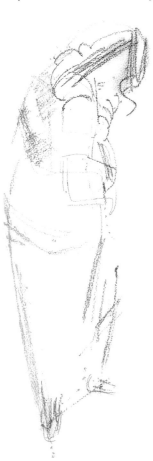

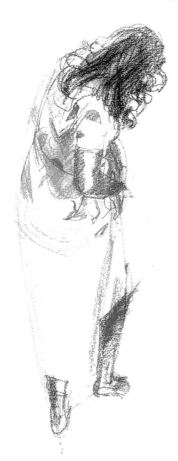

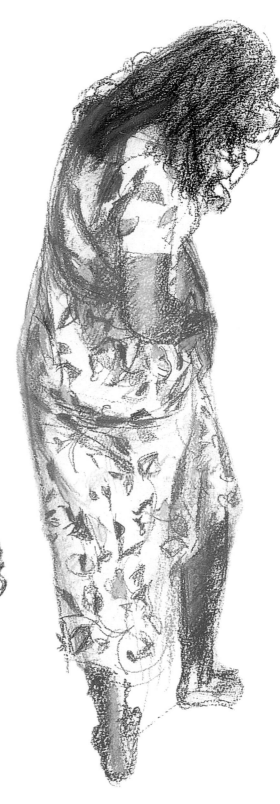

1 Establish the main pull of the dress and where it falls. The body and its balance are relatively obscured, so use what clues you can to show the folds and angles. At this stage, make marks that just suggest the head, arms and feet.

2 Add the tonality and contours of the arms. Keep checking and amending the outer edges of the dress as you develop the folds and start the patterns. Look hard at the balance and weight on the feet.

3 I strengthened some of the larger folds and set the bottom edge of the dress and its fall across the hips. The patterns help to mark out the form and pose of the figure.

4 As you reinforce the lines and marks, look for the colours in the shadow areas. Look out for any seams or fabric joins, as patterns stop abruptly at them. It is less important to get every single shape right than to feel the way it pulls across the whole form.

Quick sketches

Sketching figures in live situations, where your subjects do not pose for you or even know that they are being drawn, may seem daunting. Don't be discouraged, though – it is surprising how much you can record if you make it a regular practice.

THE SECRET OF SKETCHING is doing it. Unfortunately it is all too easy not to do it – you don't have time or the right materials, the figures are moving too quickly, and so on. The answer is to carry a sketchbook and drawing implement at all times; be prepared!

For the best chance of success, choose a spot where you can be comfortable and watch the world go by. A pavement café or park is ideal – people sit down for a while and then move on, providing a constant succession of new subjects. If your subject changes position, start another sketch. Most people have only a small repertoire of alternating positions, so they may recover their original pose. Passers-by are more difficult to catch, and you must depend on memory for most of what you put down. The more you sketch, the better and quicker you become.

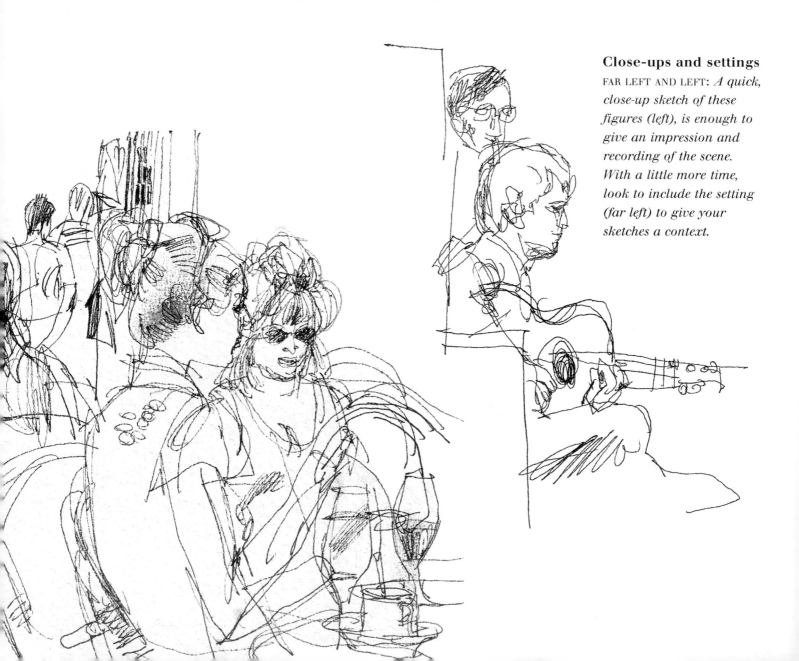

Close-ups and settings
FAR LEFT AND LEFT: *A quick, close-up sketch of these figures (left), is enough to give an impression and recording of the scene. With a little more time, look to include the setting (far left) to give your sketches a context.*

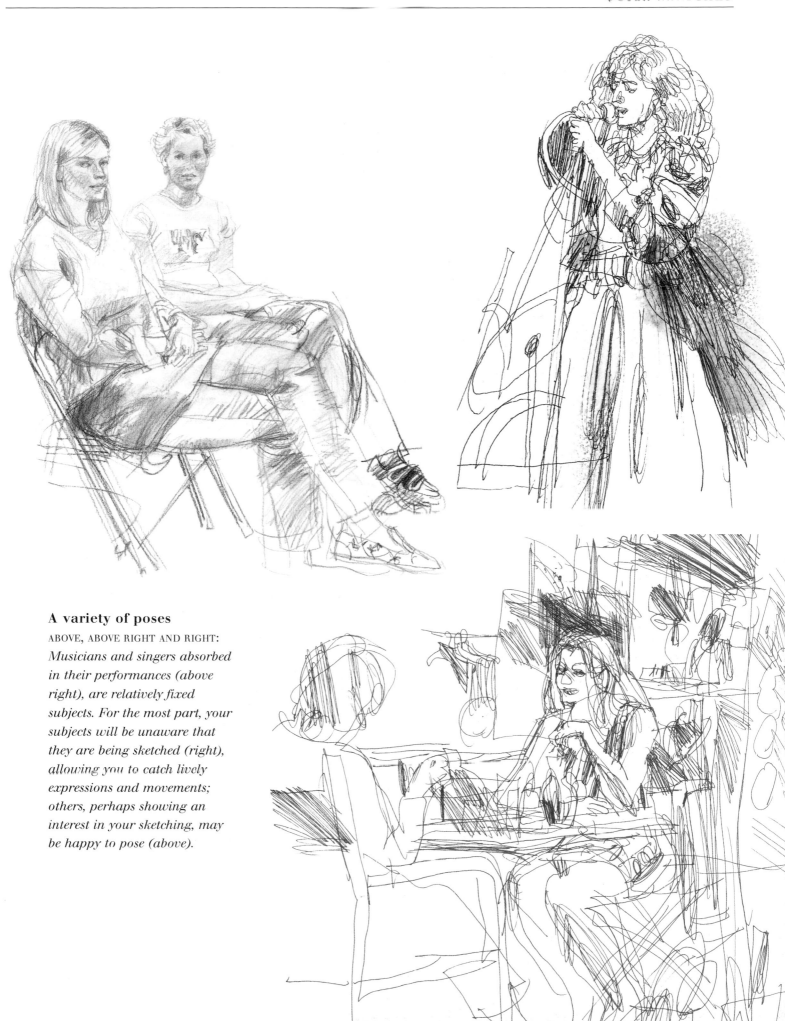

A variety of poses

ABOVE, ABOVE RIGHT AND RIGHT:
*Musicians and singers absorbed
in their performances (above
right), are relatively fixed
subjects. For the most part, your
subjects will be unaware that
they are being sketched (right),
allowing you to catch lively
expressions and movements;
others, perhaps showing an
interest in your sketching, may
be happy to pose (above).*

Seated poses

*Most portraits are of a seated subject. But there are so many ways to sit,
so many possible things to sit on. The really great portraits say something
about the sitter in their very posture, but most of us settle for a pose that
makes a nice shape and can be maintained without too much strain.*

WHEN YOU HAVE CHOSEN the pose and you are sure
that your sitter is relaxed and comfortable, you
need to ensure that rests can be taken regularly without
encountering problems in regaining the pose. Use
adhesive tape or chalk to mark the positions on the floor
of the feet and the chair legs.

If your subject is seated on an armchair or sofa, it may
be possible to record the line of a shoulder or an arm
with tape too. The progressing drawing should be
enough to record the main features of the pose between
sessions, but if you prefer to have absolute accuracy of
recall you could take a Polaroid photograph.

Remember though, that when drawing a live person
you cannot expect absolute immobility, and you must be
prepared to make changes as the sitter settles – even
relatively late in the painting or drawing.

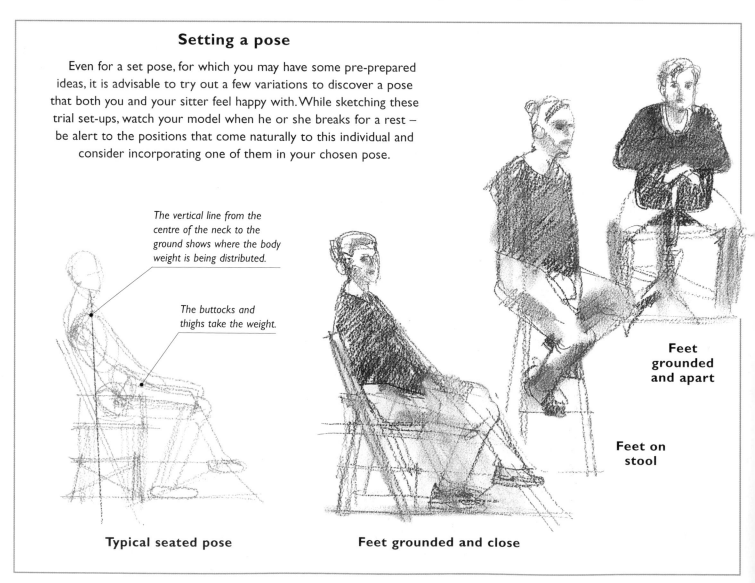

Setting a pose

Even for a set pose, for which you may have some pre-prepared
ideas, it is advisable to try out a few variations to discover a pose
that both you and your sitter feel happy with. While sketching these
trial set-ups, watch your model when he or she breaks for a rest –
be alert to the positions that come naturally to this individual and
consider incorporating one of them in your chosen pose.

*The vertical line from the
centre of the neck to the
ground shows where the body
weight is being distributed.*

*The buttocks and
thighs take the weight.*

**Feet
grounded
and apart**

**Feet on
stool**

Typical seated pose

Feet grounded and close

Practice Exercise: SEATED POSE

The pose was chosen from those on the opposite page for its qualities of formality and alignment – everything in the pose is side-on and straight except for the face, which is turned slightly towards the artist.

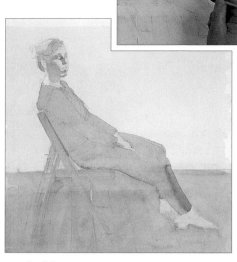

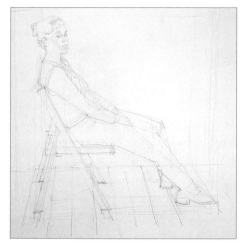

1 *Make a very light drawing, which will be lost later, to establish the structure of the figure and chair in relation to the floor. Here the floorboards add perspective.*

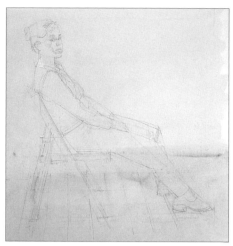

2 *I painted a very pale wash over the whole drawing, and a second one below the line of the seat, and then applied masking fluid to the nape of the neck and the top edges of the chair.*

3 *At this stage you can apply darker washes for the shading on the face and hair, and one to begin the clothing. Inset: A second pale wash reinforces the legs, floor and chair.*

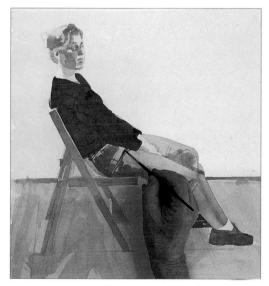

4 *A darker wash on the chair and line of the floorboards followed a check on the perspective of the whole. I then applied a light wash to suggest the shadows on the floor before making a black wash on the jumper. Seated poses always create interesting folds and creases in clothing, so pay attention to getting these right.*

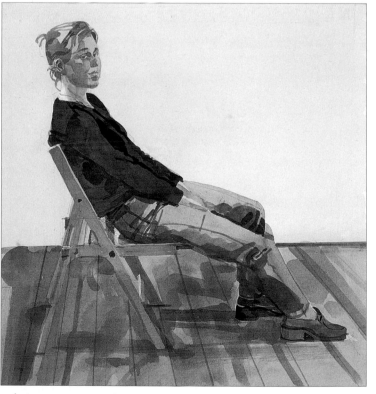

5 *A second black wash was added on the jumper, following the lines of the torso and arms. I corrected the position of the further leg and foot here, then concentrated on the cast shadows on the floor that anchor the chair and figure.*

Standing poses

After the seated figure, the standing pose is the next most likely to be adopted by a portrait subject. The first important consideration for the artist drawing such a pose is that the figure should appear balanced. Only if the dynamics are right will a standing figure appear convincing.

CONSIDERING THE COMPARATIVELY small areas that the soles of our feet provide for contact with the floor, it is amazing that we manage to balance the whole weight of the body over them. But balance we do, and it is fascinating – and imperative – to analyze how this is achieved. If the pose does not involve leaning or other partial support, the head tends to adopt a position vertically above the centre of gravity: thus, if the weight is largely on one foot, a vertical line through the centre of the head will pass through the heel of that foot.

If the line contacts the ground midway between the feet, then it indicates that the weight is being equally taken by both feet. If it is outside both feet, then the figure must be using some other support to arrest the otherwise imminent fall: this is the case opposite, where much of the weight is being taken by the chair back.

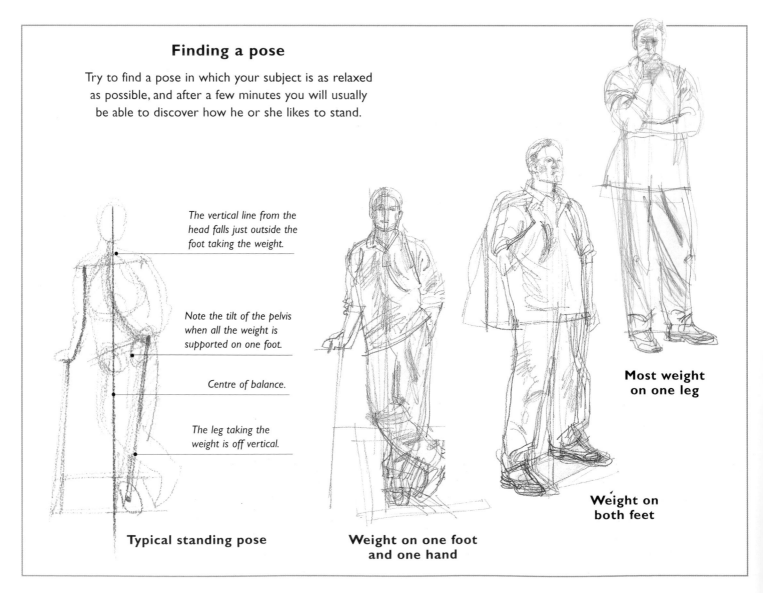

Finding a pose

Try to find a pose in which your subject is as relaxed as possible, and after a few minutes you will usually be able to discover how he or she likes to stand.

The vertical line from the head falls just outside the foot taking the weight.

Note the tilt of the pelvis when all the weight is supported on one foot.

Centre of balance.

The leg taking the weight is off vertical.

Typical standing pose

Weight on one foot and one hand

Weight on both feet

Most weight on one leg

Practice Exercise: STANDING POSE

In this study, the tension of the pose, with the figure supported by the chair, is contrasted with the looseness and soft forms of the sitter's clothing.

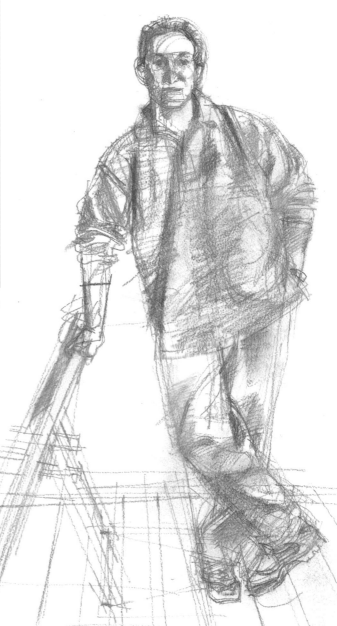

1 *Establish the vertical lines, with the head to the left of the centre of balance, and the clothes following the slope of the body. Add the floor plane to ground the figure.*

2 *The loose shirt was used to show the structure and balance: the fold from the collar moves down through the buttons and diagonally across the body. I made adjustments to the drawing as the sitter moved slightly, and the bottom of the shirt settled lower on his leg.*

3 Above: *I filled in the details on the head, checking the relationship between the chin and the shoulder and shaping the form of the shirt.* Right: *The folds of the trousers were drawn to define the angle of the legs. I used the negative shape between the shoes to define them.*

4 *Check that the angles of the right arm and the chair are correct for the pose before adding further details. Go over the key lines to reinforce the tension of the fabric, adding areas of soft tone to define the form – using pastel pencils, the colour mixing is part of this process of definition. Add the facial details and strengthen the floorboard lines.*

Reclining poses

Drawing the prone figure does not require the same attention to the problem of balance as does the standing pose, but there are still dynamic elements to consider. In addition, the sitter's support surface need not be flat or rigid: different items of furniture and added cushions will provide alternative poses.

THE HUMAN BODY ADAPTS to lying on its side by allowing the torso to sag between the relatively rigid supports of the shoulder girdle and the pelvis: the head or the whole upper trunk may be propped up on an elbow or a locked arm.

Alternative ways of vizualizing the form can be helpful: I find it useful to look at a reclining figure as though it was a long low building or even as a series of cliffs and slopes, the areas of ground or other support being the 'beach' that leads up to the cliffs.

This not only gives you a sense of the degrees of slope that a person on this beach would encounter when climbing the cliffs or slopes, but also draws attention to the shape of the beach, the 'shape left'. Then you can judge, for example, which of the 'summits' of the hip or the shoulder is the higher.

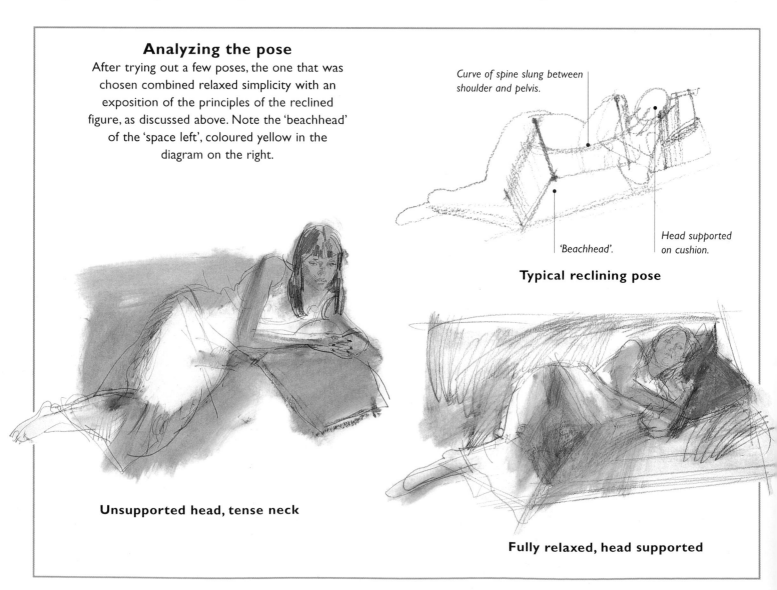

Analyzing the pose
After trying out a few poses, the one that was chosen combined relaxed simplicity with an exposition of the principles of the reclined figure, as discussed above. Note the 'beachhead' of the 'space left', coloured yellow in the diagram on the right.

Curve of spine slung between shoulder and pelvis.

'Beachhead'.

Head supported on cushion.

Typical reclining pose

Unsupported head, tense neck

Fully relaxed, head supported

Practice Exercise: RECLINING POSE

In this pose, it would not be possible for the lovely interplay between the hands and arms to be held for any length of time unless the limbs were supported by the cushion.

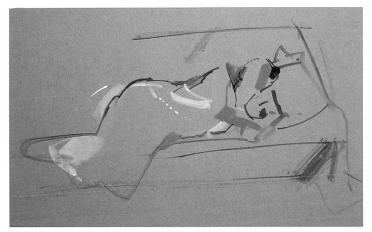

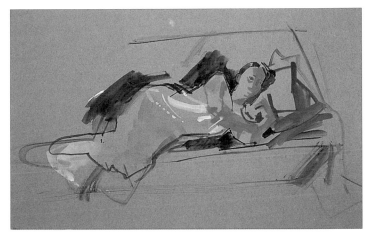

1 *Make exploratory marks to find the directions of the figure and the background – this can stay abstract until you are satisfied. The sofa and cushions are no more than outlines at this point, as is the white to suggest the fall of the dress.*

2 *Start to fill in the head and arms using simple blocks of colour and keeping your options for change open. The black behind the figure helps to fix the proportions and check the foreshortened effect of the pose.*

3 *As you add more detail to the head, look to bring the colours from the lit side of the face onto the arms and shoulder. In addition to fixing the finger shapes, start putting in the folds and creases of the clothing as it falls from the upper hip. The mass over the legs is still relatively abstract for now.*

4 *I amended the left arm before adding the cool and surprisingly warm tints to the dress. Look for the hot shadows of the hand when filling in the cushion, and note the different colours in the feet – the inside top edge of one is very warm, while the outside top edge of the other is cool with blue veins.*

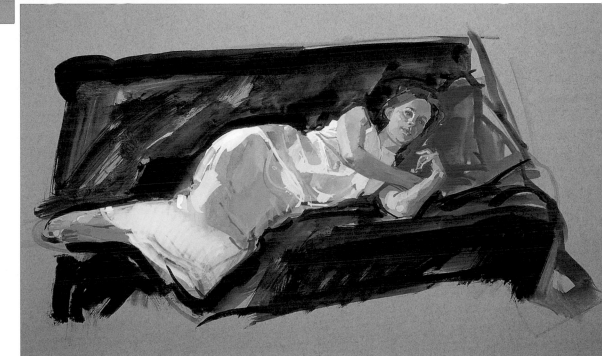

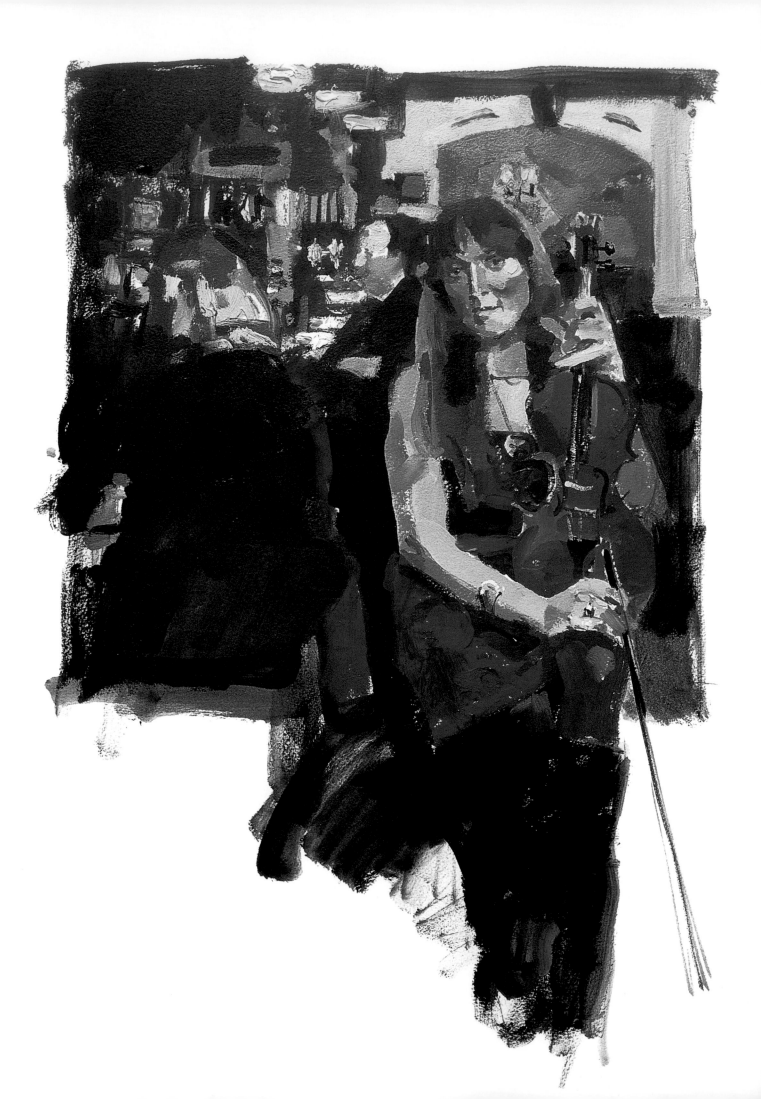

Composing
and Lighting
Portraits

In any art gallery or exhibition, the
pictures that stand out above the others are
those in which the composition and lighting
have been regarded as integral from the
beginning. Time spent learning basic principles
and knowing what the 'rules' are – even if you
then decide to break them – pays dividends
when it comes to producing interesting and
eye-attracting drawings and paintings that have
your own individual stamp on them.

Classic composition

*Traditionally, the most favoured pose for the head and shoulders portrait
has been a three-quarter front view, lit from somewhere behind the artist
and often, although not always, looking straight out of the picture – the
gaze that 'follows you around the room'.*

THE GENERAL RULE followed in compositions is to place
the subject just a little off-centre, with the shoulders
turned towards the more open space (the area defined by
the direction of the face) and the head placed in the top
half to one third of the canvas. Leonardo da Vinci's 'La
Gioconda', or 'Mona Lisa' (see opposite), is an example
of this type of composition, and there must be many
thousands of similarly composed portraits.

Needless to say, there are many variations on this theme,
but it is a 'safe' composition – it will always work well
and the basic format can be made to succeed, even when
the open space is extended into a landscape shape.
Making the standing figure half-turn towards the more
open side of the composition uses the same principle
although here the head occupies a smaller space nearer
to the top of the picture.

**The figure divides the
picture in half, with the
sitter's gaze directing the
viewer to the open space
on the right-hand side.**

**The 'V' of the bent
arm points outward,
but also directs
attention back to
the face.**

**Perspective lines help
to counter the closed
stance of the figure.**

Classical variation

LEFT: *The composition used in this portrait of my wife
is only a slight variation of the classical one described
above, the figure being almost central and facing
slightly towards the 'closed', wall side. I counteracted
this movement with the outward-pointing left foot
and the arrow shape of the left arm. Attention is
concentrated on the head and shoulders area by the
interplay between her shadowed head and shoulder
against the light background picture, and that of her
strongly lit left side against both dark and light.*

Head positioned to the left

LEFT: *This, in my opinion, is the best of the Rembrandt self-portraits and must therefore be among the greatest portraits of all time. The figure is positioned a little to the left of the central red line and turned slightly toward the more open side, and the head, with its light-catching hat and collar, is placed just above the halfway line.*

Central head position

RIGHT: *'La Gioconda' is a similar composition to the Rembrandt self-portrait above, but although the body is turned, in the classical way, towards the more open space, the head is central and the facial area is slightly the 'wrong' side of centre. Note that the near eye is exactly on the centre line*

Balancing the head position

LEFT: *The width of the head-dress and the narrowness of the skin at the neck make a strong, inverted triangle in this striking composition by Van Eyck, again slightly offset to the left of centre – on the open side. The weight of the head-dress, extended into the right-hand side, compensates for this, as does the strong outward gaze of the subject.*

Shape and space

Having considered some of the compositions employed by artists in the past, I suggest that you now set up a pose specifically to explore a simple compositional idea. I have chosen for this exercise something of a favourite of mine, the triangular composition.

IN THE SIMPLE COMPOSITION shown here, I have extended the space of the 'closed' side of the picture and introduced a more triangular composition than those shown on pages 92–3. It could be argued that my composition needs a foil to break up the empty space. However, since my subject's head is turned to look out at the viewer, and also the empty space has been reduced by not including the whole figure, the composition is acceptable without a balancing component.

Your judgement of whether a composition is satisfactory or not, is really a matter of deciding whether the arrangement looks right. There are 'rules' – like not having too many competing points of interest or not placing the main interest right against one edge or exactly in the middle of the picture – but all rules have been broken at some time or another by someone, so try out different arrangements and trust your innate sense of balance and proportion in making your choice.

Framing

Having chosen the basic pose and the triangular composition, you can still try out some variations on the outer limits of the picture. Framing to include the whole figure rendered the empty space rather large, so I chose to place the lower edge just below the long horizontal form of the thigh. The inset head, turned to look outwards, would have made a very acceptable head and shoulders composition.

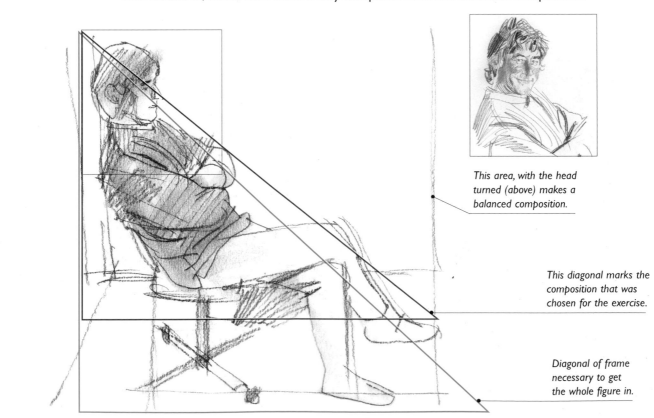

This area, with the head turned (above) makes a balanced composition.

This diagonal marks the composition that was chosen for the exercise.

Diagonal of frame necessary to get the whole figure in.

Practice Exercise: TRIANGULAR COMPOSITION

Here, an underdrawing is used to fix the chosen position. As it disappears under the watercolour washes, keep looking for it to check what you are doing – but do not rely on it without observation.

1 After deciding on the pose and making sketches, I made a pencil drawing to work from. I cropped the lower part of the drawing opposite to make the diagonal reach both corners.

2 A very watery blue wash was applied over everything except the face, hand, trousers and seat. This enhances the triangular aspect of the painting and allows you to check it for accuracy.

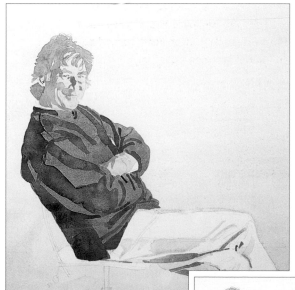

3 Give a first wash to the face and hand, then establish the shape of the hair. I applied a deeper tone to the sweatshirt. The creases at the trouser knees run counter to the main diagonal.

4 When building up the creases and folds on the clothing, seek the direction and line of each one rather than trying for an exact copy – here, the line of the near arm, reflecting the corner diagonal, is reinforced by the creases. Inset: Add the hot and cool colours on the face and fix the pupils in place.

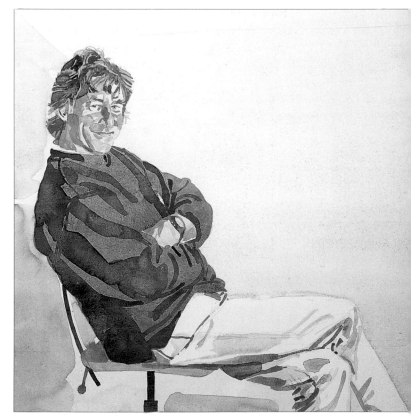

5 Use hard-edged washes – wet on dry – to fill in the dark part of the hair, leaving the original colour as highlights. Continue to fill in the details on the face, then paint the chair and the shadow wash on the left.

Breaking compositional rules

*Some artists have felt the need to push the standard 'safe' composition towards
something that may end up rather more precariously balanced. This means
moving away from the standard three-quarter-front, just-off-centre view, and
experimenting with other ways of allocating space in the picture.*

THE DEVELOPMENT OF photography, with its accidental framing leaving some elements partially cut off by the picture edge, suggested to artists how they might add drama and excitement by using similar placings in their compositions. Many great artists have experimented in this way, with successful and interesting results.

The cardinal rule that a figure should never be placed close to and facing an edge of the picture can be disobeyed and made to work by the addition of balancing elements or subtle realignments of the main subject. Use props and backgrounds to add interest, directing the viewer's gaze into and across the picture space or balancing the figure. Use colour to catch the viewer's eye. Experiment with thumbnail sketches of various compositions and formats before committing your composition to canvas.

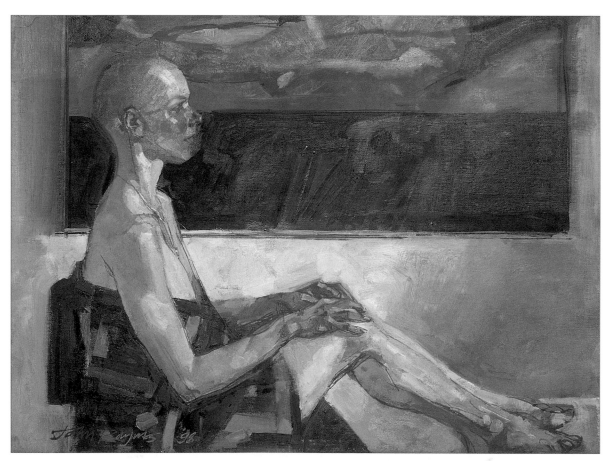

Achieving left-right balance
ABOVE: *Although the sitter's body is placed in the left-hand quarter of the canvas,
the gaze of the profiled head is so steadfastly to the right that, together with the
strong, centrally placed hands leading to the toes pointed into the opposite corner,
the composition is balanced satisfactorily. The strong bands of brown and orange
also reinforce the stability.*

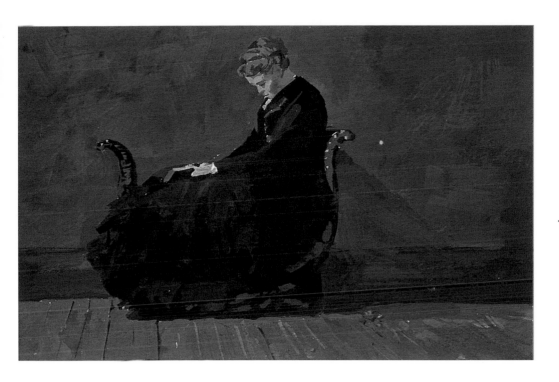

Keeping the eye interested

LEFT: *In this composition by Winslow Homer, placing the seated profile figure so much in the left half of the composition could court disaster. The triangular cast shadow from the curious chaise-longue helps to create a central shape, but it is the pink rose on the floor that catches the viewer's eye and drags it back to the otherwise uninteresting right-hand side.*

Portrait or still life?

RIGHT: *Probably one of the most extreme examples of pushing a portrait nearly off the edge of the canvas, this painting by Edgar Degas is one of many in which he used compositions akin to those in the new craft of photography. Not only is the woman placed in one quarter of the picture, but she is also turned towards the edge and she is looking out of the picture! It could be argued that this is not a portrait at all, but it is a daring compositional use of a figure.*

Using empty space

LEFT: *In this offbeat composition by Jan Vermeer, centuries before the invention of photography, the figure is placed almost entirely in the left half of the frame and is looking to the left, as if at someone out of picture – there is almost nothing of interest in the right-hand half of the composition. The factors that make it work are, first, that the body faces towards the empty space, and second, that the hands and guitar make a strong line leading back into the shadowed right half.*

Using source materials

*In order to make a definitive portrait, you may have to gather information
from a number of different sources. Making preliminary studies is a good
way of getting to know a face, and if one of them seems to be right you will
need a method to transfer your information onto the finished portrait.*

A S WELL AS MAKING studies of your sitter, you may have
access to photographs. There may also be a choice
of background or setting. All this source material should
be gathered together and sorted – it is a good idea to pin
it all up on a board or a wall and take time to decide
which items best evoke the character of your sitter.

A photograph, to take the most obvious example, may
have a small emphasis of expression that your studies
have missed and which you consider to be typical: keep

this by the study to refer to when you are working on
the final painting. For a large painting, it is a good idea to
make a well-sorted-out composition at a smaller, easily
manageable size.

When you are satisfied with the arrangement you will
need to enlarge it and transfer it to the final surface.
There are several ways to do this, including relatively
expensive optical projections, but the most usual and
foolproof method, squaring-up, is described below.

Practice Exercise: SQUARING-UP

In addition to transferring an image from one source to
another, you can use this exercise to make changes or
amendments to the composition.

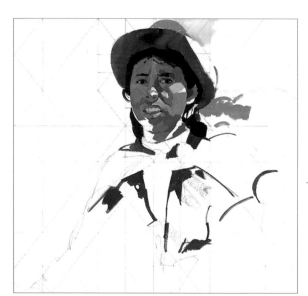

1 *With a photograph, either
lay tracing paper over it or
make a photocopy, and draw
a square or rectangular grid of
the area you wish to use,
breaking up the areas with
diagonal lines.* Inset: *Make
sure that your trace is clear
enough to be worked from.*

2 *Draw an identical grid on your chosen support,
keeping any changes of dimensions consistent
throughout. Working one section at a time, transfer
the drawing from the original to the new grid,
observing closely at all times and using smaller
grids for more detailed areas. Continually refer to
the original subject, and work across the whole
picture as you go.*

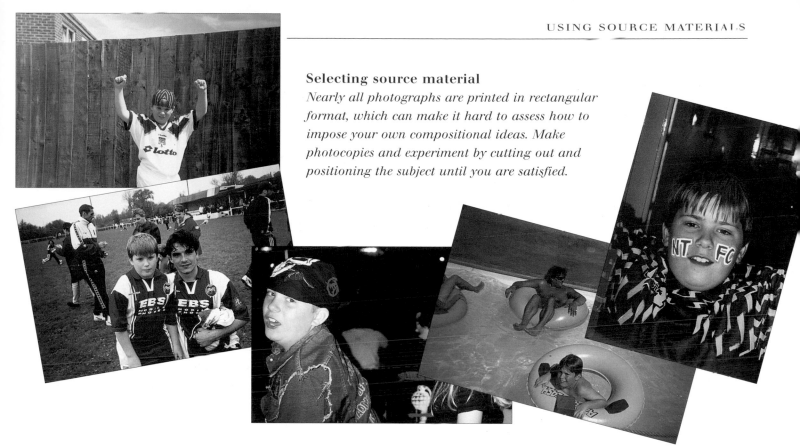

Selecting source material

Nearly all photographs are printed in rectangular format, which can make it hard to assess how to impose your own compositional ideas. Make photocopies and experiment by cutting out and positioning the subject until you are satisfied.

Composing a montage

RIGHT: *When composing a composite portrait, you should decide first which image will be the dominant one. Then position it in a prominent and eye-catching position, not necessarily central, and experiment with placings of the other subsidiary subjects around it. Varying the sizes and the scale of the minor motifs helps to make it clear that they should not be read as objects in real space.*

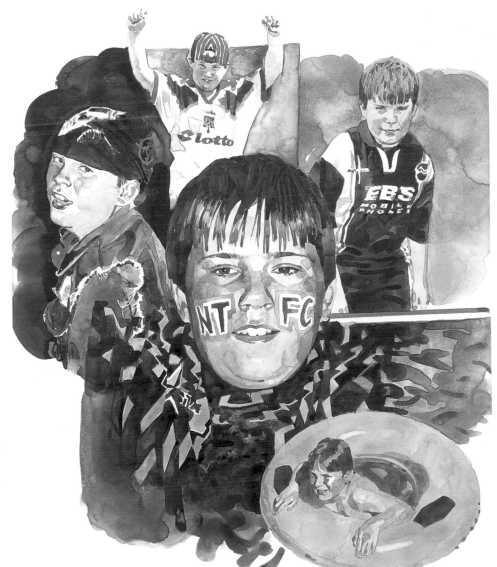

Backgrounds

In some ways simple backgrounds are more difficult to manage than complicated ones. It depends on how venturesome your composition is to be; when there is only a small area of background, it is only a matter of choosing colour and tone, but the choice of background is much more critical in large areas.

A PLAIN, DARK BACKGROUND has the effect of concentrating attention on a frontally lit head, and this has been the favourite formula for thousands of traditional, formal portraits. However, you should be aware of other ways of organizing the space – for example, a head not lit from the front and with darker areas of shadow as a result, will probably work better against a lighter background.

It has become rather fashionable to incorporate large, relatively empty spaces in portrait compositions. Probably the easiest position for a large space is in the upper part of the picture, with the portrait at the bottom. Harder to manage are large blank areas to the left or right of the main subject, which may require some balancing point of secondary interest, such as a prop, and/or tonal gradations.

Landscape as background

The landscape behind Thomas Gainsborough's portrait of Mr and Mrs Andrews was no doubt included to proclaim their status as eighteenth-century landed gentry, but it is also a great visual enhancement of the portrait and an invitation to the viewer to wander around in it.

All the human interest is contained in the left-hand half of the canvas, reinforced by the bulk of the tree trunk.

Strong cloud formations add interest to the right-hand half, and the curving furrows steer the eye back to the figures.

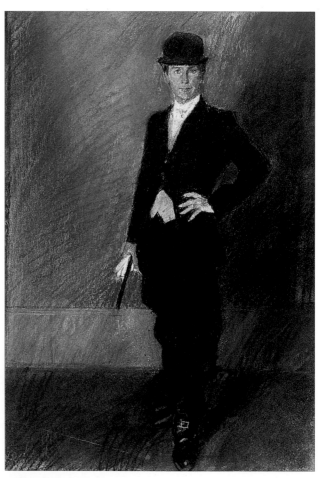

Simple background

ABOVE: *A plain background concentrates attention solely on the portrait subject. Definition of the line where floor meets wall and shadow shapes – real or invented – can be manipulated subtly to further highlight the bold pose.*

Detailed background

ABOVE: *This portrait of a celebrated Parisian chef was drawn as an illustration for a magazine. The intention was to show the chef in front of, but not as a part of, the background of diners enjoying the ambience of his restaurant. The background, however, is not simplified and features almost as much detail as the foreground figure.*

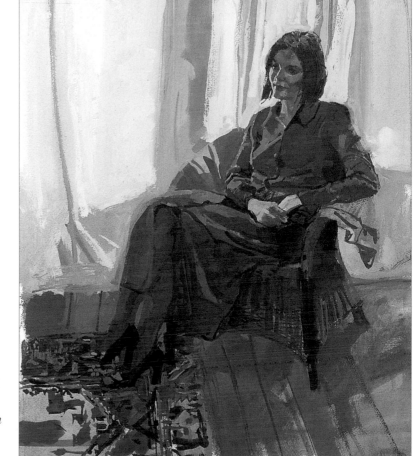

Translucent curtain

RIGHT: *The folds in the background curtain modify the filtered light from the window and provide an interesting, vertically banded pattern of closely related colour. The section of patterned carpet in the bottom corner is an integral part of the composition – see how bland the effect is when you cover it up.*

Detailed backgrounds

Backgrounds to portraits do not have to be plain. They can incorporate almost anything from ornate interiors to wide landscapes, from fantasy realism to abstract pattern. In a portrait, though, however rich and interesting the background you choose, the figure must be able to compete with it.

A PORTRAIT BACKGROUND is normally expected to have some relevance to the sitter. The obvious solution is to use the home or work setting of the sitter as the background. If it is intended that the portrait subject should appear actually to be in the surroundings that you have chosen, ideally you should draw on site, so to speak, which obviates any perspective or scale difficulties. When this is not possible, importing a favourite chair,

screen or other furniture may be the answer. Some artists even resort to building a rough representation of a room and its furniture to be sure of getting the scale right, especially valuable when painting a group portrait.

For this study, I gathered together several items from the sitter's large collection of oriental artefacts, grouped them in a pleasing arrangement and then emphasized the pattern by a certain amount of abstraction.

Practice Exercise: PATTERNED SETTING

Select props and a setting that reflect your sitter's interests, then arrange them in such a way that their patterns and textures create a semi-abstract design as a background.

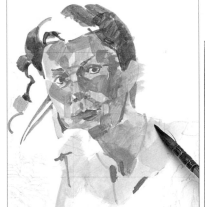

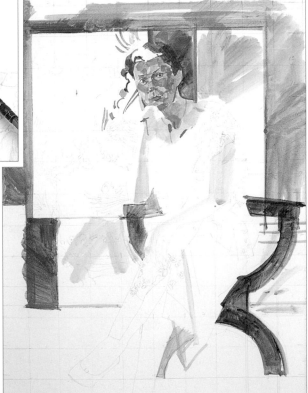

1 *I used two or three sources to choose and gather together the parts that created this squared-up image. When working in this way, it is vital to check that the light conditions are the same in each element, or the result will not be convincing.*

2 *Start to block in the background, using the screen to set the formal framing. At this point look for abstract background patterns – the details can come later.* Inset: *Establish the tones across the sitter's face.*

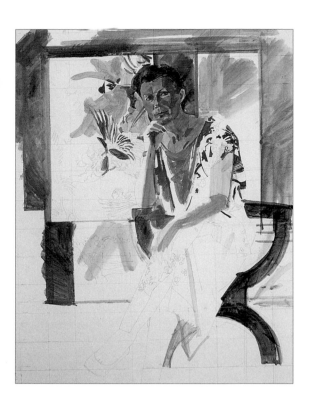

3 *The patterns on the background kimono and the sitter's dress were too large to be painted as texture, so I drew their individual shapes, even if these were somewhat simplified. Taking photographs as you paint is the best way to record patterns and folds.*

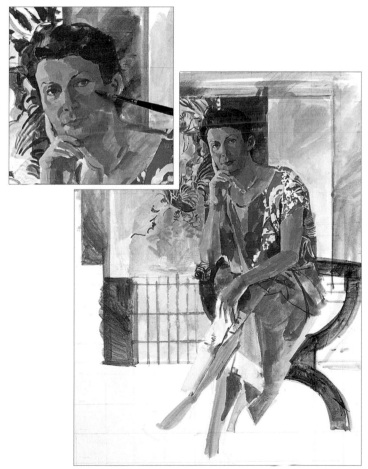

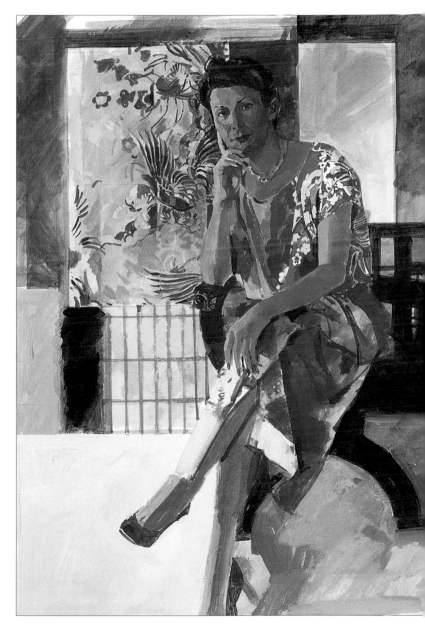

4 *Add darker washes to build up across the whole picture. I looked for echoes of the dress in the kimono, and contrasted them against the rigid grid of the screen. Inset: Keep checking the tones of the face as you build up the background colours.*

5 *Use broad strokes to fill in the floor area, paying attention to the negative spaces, and finish the legs and feet. Reinforce the shadow areas with thin, light washes before reinforcing the shape and details of the chair.*

Props

*There may be occasions when more than a relevant background is
needed to underline the character of a subject or to make a more
interesting picture. Props, such as a pair of glasses, can be worn or held
by the sitter, or can be separate and treated as a still-life exercise.*

MUSICIANS MAY LIKE to be painted with their
instruments, or a craftsman with his tools. Pets are
popular props, as are books or flowers in the hand.
Outdoor portraits offer possibilities, such as parasols and
straw hats that cast speckled shadows on the face. Your
subject could dress up, donning clothes that they would
not normally wear, maybe sports clothing or the uniform
of a profession. Hats, veils, fans, even masks can be used
to dramatize the image, and you can view your subject
through foreground objects such as lace curtains or
plants. Of course, there is no need for the costume and
accessories to have any relevance at all other than to
express a sense of fun or fantasy.

Don't forget that the image can be yourself.
Rembrandt, perhaps the most prolific of self-portraitists,
pictured himself with a large variety of hats and a
helmet, even holding up – and almost hidden behind –
a dead bittern!

Tools of the trade
ABOVE: *Craftspeople at work are always interesting to observe and draw,
particularly for their unselfconscious attitudes and concentration. By
placing your sitter in a familiar setting with props that reflect their
character and interests, you will achieve a natural portrait.*

Traditional costume

LEFT: *Sepia and black watercolours were used for this portrait of a Japanese girl. The fan is an important part of the composition; it is used to complement the traditional costume and adds interest to the foreground.*

Using patterns

ABOVE: *In drawing this lady in a flowery hat I wanted to make the most of the contrasting patterns in her flowery hat and dress. I used coloured (wax) pencils on abraded-surface paper.*

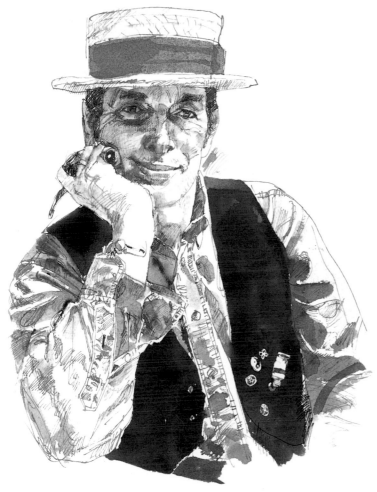

Small props

LEFT: *This man does not always wear his straw hat, but he is rarely without his pipe, his paint-tube brooch and his ying/yang badge. Such seemingly insignificant details can bring a portrait to life.*

Bringing it all together

The subject of this oil sketch is a violinist who plays a variety of venues, including pubs and clubs. Although she posed in my studio, I have set her against a more appropriate background. You can add a background in one of two ways: it can be treated almost as an additional element, as here, where there is no pretence of a real spatial relationship between the main figure and the background. Alternatively, you may wish to surround your subject with a new set of background features so that the viewer is convinced that they really co-existed – for this type of illusion to be successful it is essential that the lighting is consistent and that the perspective links between the main figure and components of the background are really convincing.

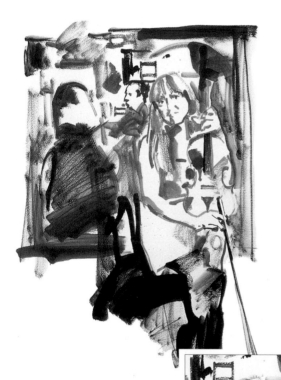

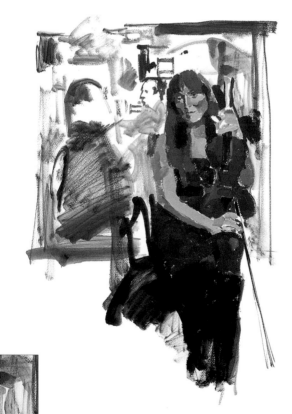

1 *Block in the main shapes of the figure, using uniform mid-tones. Even though no details are being added at this stage, be aware of what will be needed: here, note that the hand is holding the bow behind the horsehair.*

2 *Add the main shapes in the background, using broad brush-strokes and very diluted paint. I decided to bring the focus fully onto the figure by filling in the background only halfway down. Inset: The red mixed for the dress was applied to the subject's cheeks.*

3 *Fill in the hair and begin to add the skin tones: in a quick sketch like this, the detail does not have to be precise, but it must include all the tones, however broadly they are painted.*

106

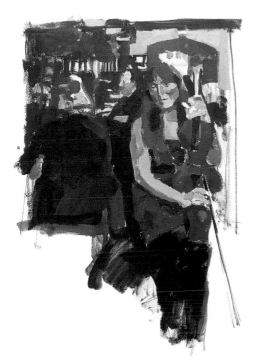

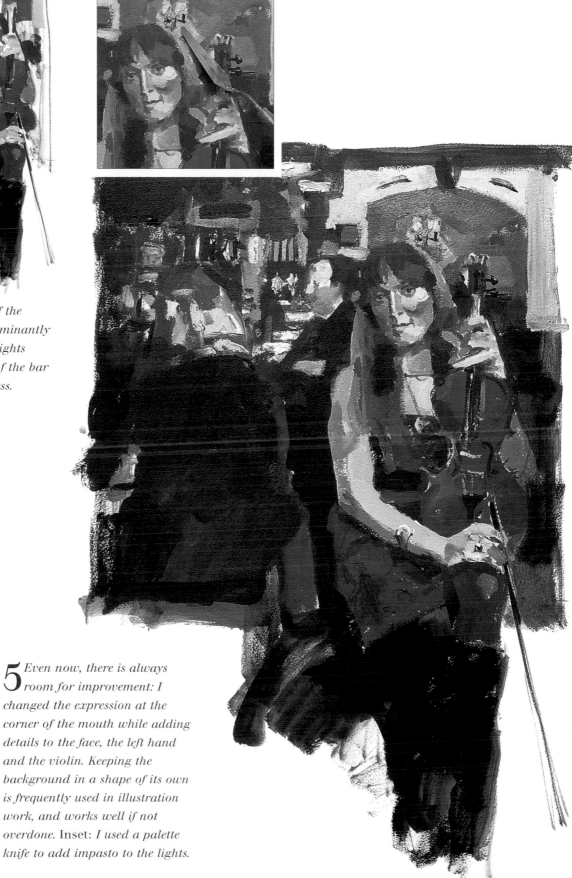

4 *Fill in the white spaces of the background, using predominantly cool colours and letting the lights shine out. Note that the red of the bar matches the colour of the dress.*

5 *Even now, there is always room for improvement: I changed the expression at the corner of the mouth while adding details to the face, the left hand and the violin. Keeping the background in a shape of its own is frequently used in illustration work, and works well if not overdone.* Inset: *I used a palette knife to add impasto to the lights.*

Natural light

*Drawing and painting a subject lit by the direct light of the sun presents
certain difficulties. Apart from the erratic appearance in many climates,
the colour and direction of light and its consequent cast shadows are
constantly on the move as the day progresses.*

DIRECT SUNLIGHT FALLING on a subject through a window can be very attractive and interesting to paint, wherever the window is facing, so it can be worth putting up with the considerable difficulties caused by the constantly changing light source. As the sun moves around, not only does the pattern of light on the face change but so also do any cast shadows from window glazing bars or other objects. This necessitates either working very quickly and only for short periods every day when the light is right, or recording your preferred sunlit situation with the aid of the camera.

In the long run, a combination of these methods is most likely to be successful. You could, for example, try painting or drawing from direct observation and then at the point when certain key shadows are just right, taking a photograph to record the light fall for later reference.

Indoor sunlight

RIGHT: *A self-portrait of this type
is clearly going to be well-nigh
impossible to make without using
photographs – apart from the
constantly moving cast shadows
from direct sunlight, in this position
a mirror view of yourself would be
obscured by your painting surface
and support. I set the camera on a
tripod and took many pictures to
find the most interesting pattern of
bars of light and shade playing on
the already complex arrangement
of objects and surfaces. Here, the
strongest sunlight falls on the lower
legs, while the face is in shadow.*

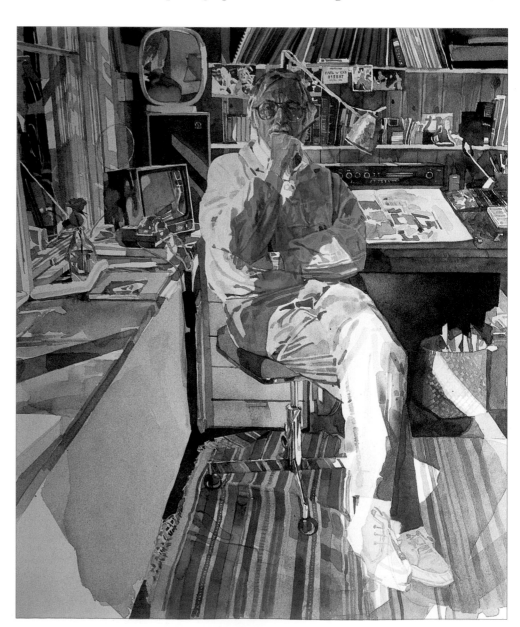

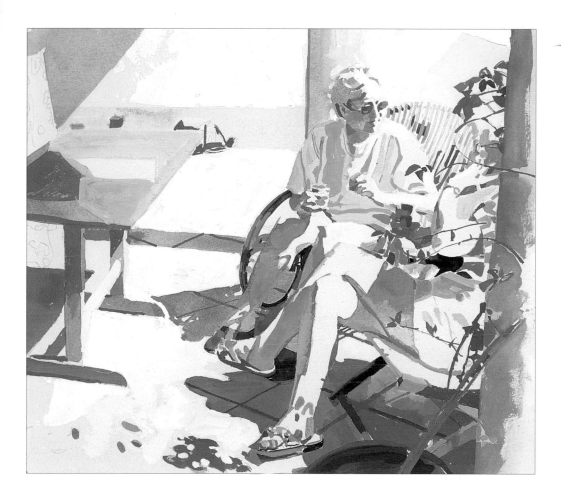

Bleached out

ABOVE: *Occasionally you will have taken a holiday snap that, by over-exposure, has resulted in a bleached result rather like this. A failure? Not necessarily so. Think back to the occasion, the glare of sunlight from white surfaces, the way you had to screw up your eyes to see anything at all – perhaps this pattern, with bleached-out lights and coloured shadows, better represents the situation than an image with all the lights and highlights carefully modulated.*

Dappled sunlight

RIGHT: *Splashes of sunlight filtered through leaves and branches make unique patterns on anything they touch. Similar patterns may be seen from the brim of a straw hat, or indeed anything with perforations to let the light through. They may seem confusing and destructive of the form, but have courage and draw what you see – the eye will accept them, not as substance but as light.*

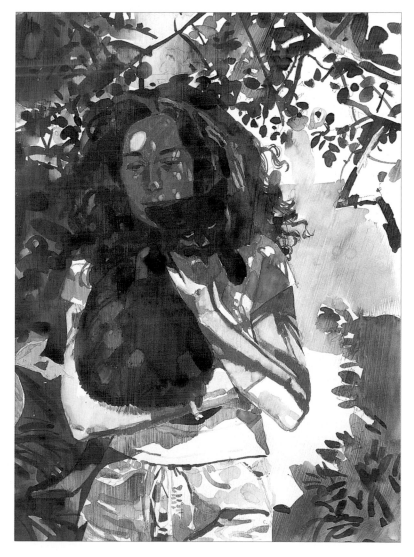

Diffuse light

A studio with north light is considered to be the ideal: light from the northern sky is indirect and therefore much less changeable during the day than direct sunlight. In the southern hemisphere the opposite is true, the sun moving through the northern sky during the day, making south light the best choice.

NOT ONLY IS LIGHT that is reflected from the north sky (or south sky in the southern hemisphere) more constant and reliable than direct sunlight, it is also softer and more diffuse. A face illuminated by it has no hard-edged shadows and much less pronounced, if not entirely absent, cast shadows. It is the favoured light for the vast majority of portraits, both for the reasons above and because it is generally rather flattering.

If you place your sitter to be illuminated directly by north light, the result will be very flat and shadowless, rendering very subtle tonal variations from light and shade, while giving changes of colour more prominence – a pale-coloured face and dark hair seen in this light provide a good example of this effect. The face, devoid of strong shadows, will reveal its outline shape in maximum contrast to the surrounding halo of hair.

Study in north light

RIGHT: *This oil-paint sketch was made on a small panel surfaced with scrim (like a coarse muslin) and gesso made of rabbit-skin glue and chalk whiting. This makes a very open, coarse finish that is ideal for rendering the soft gradations of diffuse light.*

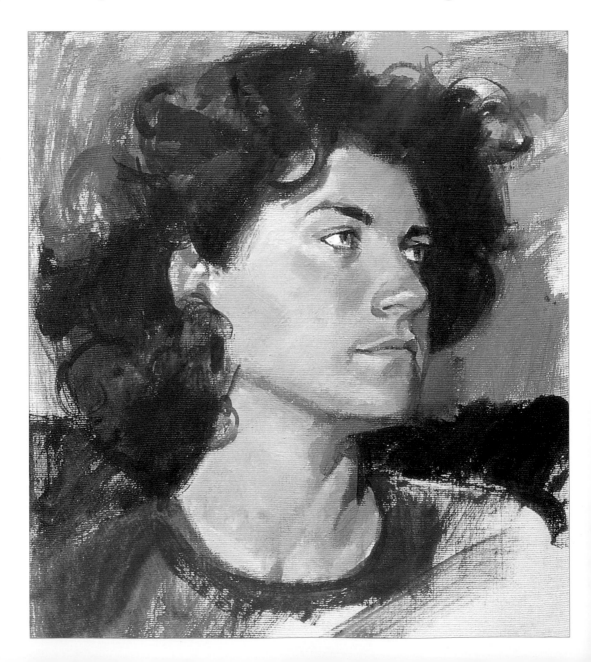

Practice Exercise: FLAT LIGHT

Using a dark-coloured pastel paper for this exercise means
that you are forced to look hard for clues to contour and form,
rather than cutting corners and making assumptions.

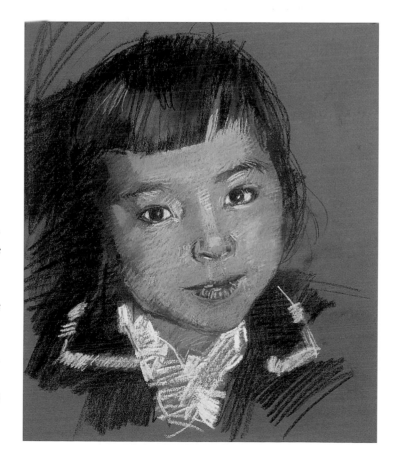

1 *Using a light pastel, start by establishing the shape of the face and the relationship between the features. Because of the lighting, the structure is quite flat, with few contrasts.*

2 *Set the sides of the head and indicate the fall and colour of the hair. Mark where there are changes in the surface – nostrils, eyes, middle of nose – and fix the position of the iris and pupils.*

3 *Add cool shade colours where there is any shadow – on the sides of the face – and begin to solidify the colours. There are hardly any highlights. Inset: The lips are the hottest face colours here.*

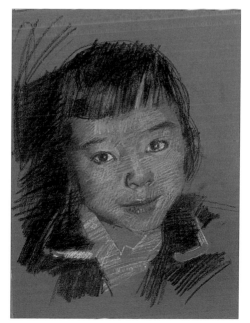

4 *Having fixed the drawing to keep the basic structure, I used a sharp pastel pencil to add the smallest details, before adding further colours to define the slope down from the middle of the nose and the sides of the face.*

5 *Even at this stage, there is room for change – I made the jawline squarer to the chin. Horizontal pastel strokes were used to even out the colour across the top of the nose and the forehead; these were blended to reinforce the flat lighting.*

Contre-jour

Contre-jour means 'against daylight', and this striking technique involves backlighting the sitter and using reflected light to illuminate him or her. Finding the right reflection is worth the effort, as the combination of soft light and a rim of bright-edge lighting has a sparkling quality.

IN BRIGHT SUNLIGHT there is often enough light reflected back from the surroundings to provide secondary illumination to the side of the backlit sitter facing you, so that you can determine their features. Although the eye automatically compensates to some extent for the low-level reflected light by widening the pupil, you may need to set up some similar reflective surface to help you to see the front side comfortably.

Indoors, with your subject against the light from a window, you will need a reflector of some sort – white card or a polythene sheet, leant on or propped against a chair, usually works.

When taking photographs for later use, the effect of sunlight is rarely enough for photographic film to pick up, and you may need to direct reflected light from a white or silver reflector onto the shadowed (front) side.

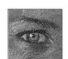

'White' of the eye is blue/grey – compare with bright white at rim of hair.

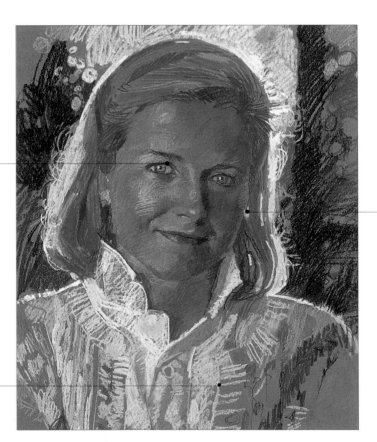

Cool blue/green reflected light in shadow area.

Ground colour of paper shows through white and pale blue pastel strokes.

Strong reflected light

ABOVE: *If the halo of direct back lighting was removed from this picture it would still seem well lit, such is the strength of the reflected light. There are even strong shadows by the nose and upper lip, as though from a primary light source. To achieve this degree of reflected illumination, place a bright white or silvered surface in front of a backlit sitter.*

Practice Exercise: FIGURE BY A WINDOW

The advantage of working with watercolour and body colour on primed acrylic board is the translucent effect – ideal for depicting light.

1 *Apply warm, reflected-light colours to begin. The surface slows the paint's drying time, so add it where you can, not touching wet areas. Throughout the painting process, remember that all colours are reflected.*

2 *Start the background – you can apply dark colours and reduce them later by lifting off or diluting them. Inset: With reflected light, there are warm and cool colours at the same time.*

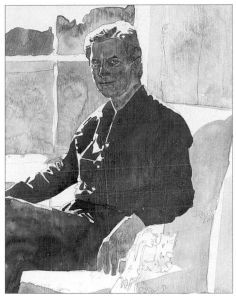

3 *Add the dark areas to the face, and the hot colours around the eyes – these are more extreme than if the face was lit. While the face was drying, I filled in the shirt, leaving the parts directly in the light as white.*

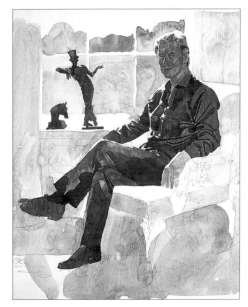

4 *I reworked the head area in shadow, using body colour after pulling out the highlights. With the light behind the dark statues, I could concentrate on the shapes.*

5 *Once the washes are dry, body colour is best for adding the facial features and details. I built up the hand, chair, darker tones and negative spaces, keeping an eye on the highlights and edge lights, and then suggested the flooring and the wood of the chair. Use body colour for detail if the watercolour lifts out too readily.*

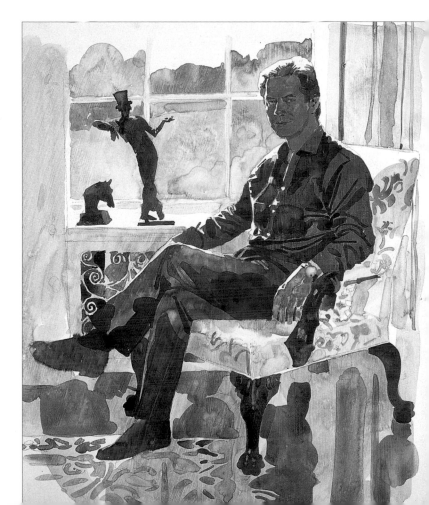

Artificial light

*Artificial light – light generated by sources other than the sun – can take
many forms. Nowadays it is provided by electric lighting, ranging from a
single, white light bulb to a huge multiplicity of spots, floods and lasers in
a myriad of colours that are used to light theatres and music concerts.*

THE OBVIOUS ADVANTAGE of electric light is its unvarying
direction and intensity. Its principal disadvantage is
that it produces a comparatively hard light with clearly
defined cast shadows, although this very characteristic is
what compels some artists to choose it.

If you paint by artificial light and would prefer
something more like natural light, it can be softened by
various means. You can bounce (reflect) the light off a
light-coloured wall or ceiling onto your sitter, using a
high-powered directional source such as a reflector
lamp. Baffles in the form of paper or fabric lampshades,
the bigger the better, soften the light. For the same
purpose, photographers use a 'soft box' consisting of a
powerful light in a large reflective umbrella with
translucent white fabric across the front, a not
impossible thing for a practical person to construct.

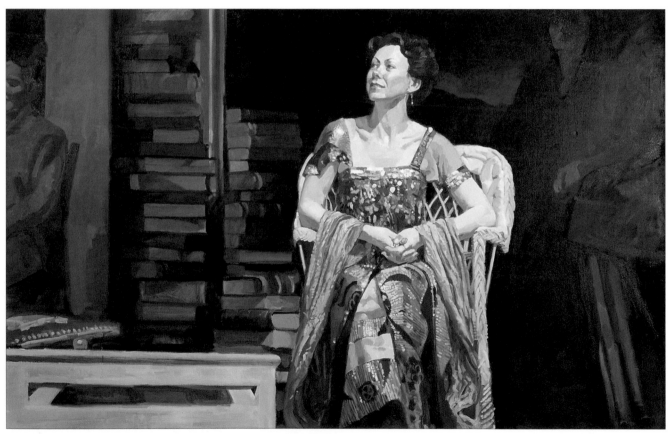

Theatrical light
ABOVE: *The stage lighting that delighted Edgar Degas and Walter Sickert
may now be a thing of the past, but complex arrays of every type and colour
of light now enable stage-lighting operators to produce amazing and
brilliant effects. I tried out a variation of this portrait, of the celebrated
actress Jenny Agutter, against a glowing gradated-orange backcloth before
deciding on this strongly spotlit version.*

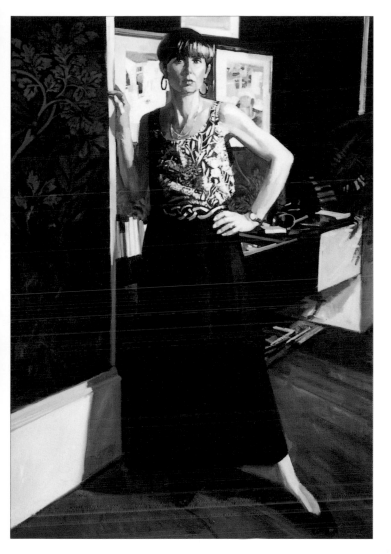

Diffused light from a single-source

LEFT: *The lighting in this portrait may resemble natural light, but the figure was lit with a single light in a large diffusing reflector. Known sometimes as a 'softbox', this is used by photographers to make electronic flash illumination less harsh than direct unfiltered flash would be.*

Lighting by electric bulb

RIGHT: *Some artists, notably Lucien Freud, like to use the unforgiving nature of light produced by a powerful, unshaded electric light bulb. This provides hard cast shadows, and the colour is much more yellow than any form of daylight.*

Combining portraits

*When placing several heads or figures in one composition, you must decide
first whether you are portraying an actual situation, or simply combining
elements to make a pleasing pattern. Remember that the areas around and
between the figures are as important as the figures themselves.*

IF YOU DECIDE NOT TO represent real space, you can theoretically incorporate any number of images in one composition. They could include different people, different views of the same people, whatever you wish.

In general, multi-images of the same person should be avoided, but there are occasions when a single image may not be quite enough. An example of this is the composite drawing of my great-nephew on page 99. No single photograph quite captured his personality, and a composite was the only solution.

For the non-spatial arrangement in the exercise opposite, no consideration was given to whether the boys could have sat as portrayed, and they were combined into a pleasing composite shape.

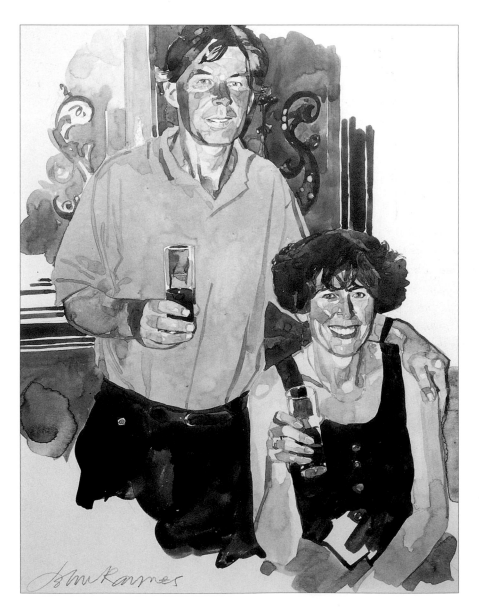

Using real space

LEFT: *In this double portrait, the couple
are in a real, common space, confirmed
by the man's hand resting on the
woman's shoulder and the shared
background. Note that the figures and
background are incomplete, trailing off
to a broken edge; this arrangement is
known as vignetting, and is particularly
suitable for watercolour paintings and
pastel drawings.*

Practice Exercise: COMBINING TWO FIGURES

With separate portraits combined, as here, you can concentrate on the portrait as a pattern, and choose the expressions you want. Make sure that the lighting conditions are identical.

1 To find your composition, make tracings, perhaps from separate sittings. Inset: Fill in the reverse with graphite stick, then transfer onto paper.

2 Because you already have traced the shape and structure, you can go straight to creating tone, form and some detail. Starting from the top left-hand corner reduces the risk of smudging.

3 Use hatching and crosshatching for the hot colours around the eyes and the cool ones in the shadow areas. Keep looking across the whole picture as you continue to describe the form.

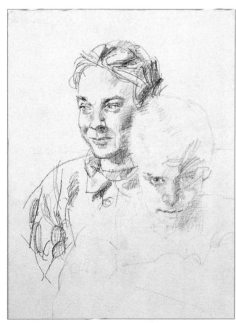

4 The right side of the foreground figure's face is largely in shadow. I opted to use a very light touch, just resting the pencil on the surface, to create a 'fugitive' effect here. Add more to the background figure as necessary.

5 The foreground figure's clothes are the strongest tones in the drawing – note the hard edges where they meet the head on the 'lit' side. Loose hatching suggests the movement of the hair, with blue highlights. The horizontal lines behind the figures are invented – I added them to give compositional interest.

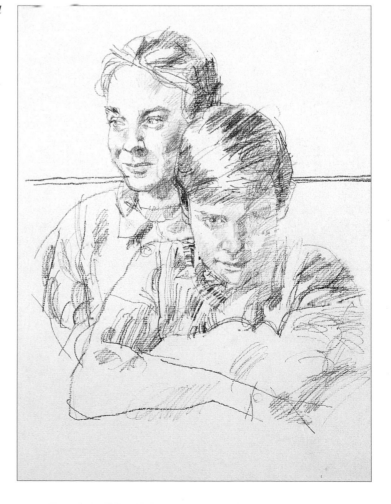

Group portraits

The best way to compose a group portrait is to get all the participants together at least once and move them about until you are happy with the arrangement. Then you will need to record the composition in some way, in order to fix the individual positions for later sittings.

THE REASON FOR composing a group portrait live is the difficulty of solving all the problems of perspective and scale if you do not. In some group portraits, it is obvious that they have been badly pieced together from different sources. Because it is not always possible to assemble all the figures in one place at the same time, the artist must learn the relevant perspective principles.

Aim to bring everyone together in the same light and preferably in the situation that you intend to use for the finished work. One method is to assemble the sitters and view them through a sheet of transparent plastic, outlining their positions in a variety of paint colours as you consider the alternatives, one of the colours denoting the final choice.

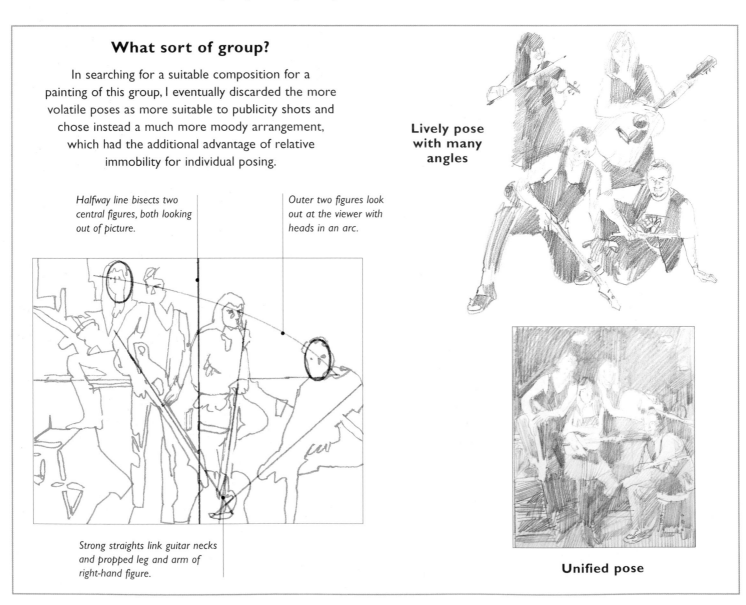

What sort of group?

In searching for a suitable composition for a painting of this group, I eventually discarded the more volatile poses as more suitable to publicity shots and chose instead a much more moody arrangement, which had the additional advantage of relative immobility for individual posing.

Halfway line bisects two central figures, both looking out of picture.

Outer two figures look out at the viewer with heads in an arc.

Strong straights link guitar necks and propped leg and arm of right-hand figure.

Lively pose with many angles

Unified pose

Practice Exercise: DETAILED GROUP

However easy it may be to work separately on each figure in a composite group portrait, avoid this if you can – working across the entire picture will provide unity and wholeness.

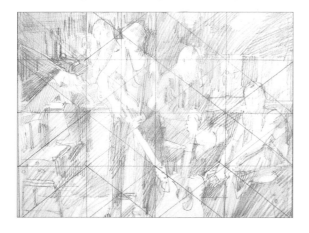

1 With the composition of the group arranged as I wanted it, I overlaid the drawing with a grid and squared it up (see page 98) before lightly sketching it onto the canvas. This is also a useful exercise for checking the relationship between the figures.

2 Use thin layers of paint to put down enough colour information to separate the light from the dark areas. Allow for shadows in the background.

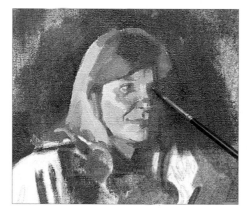

3 Add the base of the dark tones and colours in the figures – this will help to set the angles and relationships between the figures.

4 Here, each figure was painted in turn. Cover each area so you can judge the tones for the details, and use the drawn lines as structural aids.

5 As you work across each figure – as in a sitting – look for both the positive and negative shapes that relate to the other figures and their props.

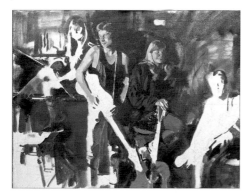

6 The figure holding the bass guitar is closest to the light source, so his skin required lighter tones than the others, who are more in shade. As you work, continue to fill in the background spaces.

7 I added the details on the bass guitar; even though it is black, it has the most highlights in the portrait. Continue filling in and detailing the figures and background, always checking that the dynamics and angles are as you would want them.

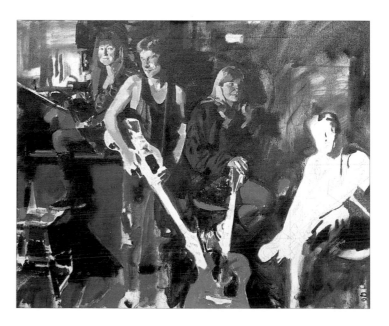

Groups outdoors

Drawing and painting people outdoors offers the artist an enjoyable challenge. The constant flux of figures creates varied compositions and the variety of backdrops makes a refreshing change from the studio. The variable effects of light and weather will keep you on your toes!

As NATURAL LIGHT CANNOT be relied upon for consistent brightness and direction, you will need to make sketches and take notes while you work outdoors. You could take a photograph, but it is often more difficult to make a drawing or painting from a two-dimensional photograph than it is to work from the three dimensions of reality. When representing a group of people, make sure that the direction and fall of light is consistent across the picture. Be aware of the effects of strong shadows and direct light: you can make them into part of your composition.

You may wish to make a figure composition which tells a story, an allegory perhaps, a decorative pattern or a mural. For this, gather your studies and any references together, and compose freely without the restraints of consistent light and coherent space.

Bus queue

ABOVE: *People waiting in line might not seem to be a stimulating subject, but take a good look at this group. The baggage on the ground and in the hand, the varied clothes and stances, the figures on different levels and the strong background passages of light and shade, all contribute to the rich pattern.*

Fête day

LEFT: *The sweep of deep blue sky was an important part of the composition, and was applied with a broad brush. The car in the foreground leads the eye into the picture where the couple provide the focal point. The bright, overhead sunlight creates strong shadows on the couple's faces and clothes and creates shiny highlights on the car.*

Beach scene

RIGHT: *Wonderful compositions occur on beaches, and many of the figures are inert for long periods – which makes things easier! Get into the habit of looking around you with that special abstract vision that sees shapes and grouping rather than individuals. Then, record the patterns that excite you with camera or sketchbook, or both.*

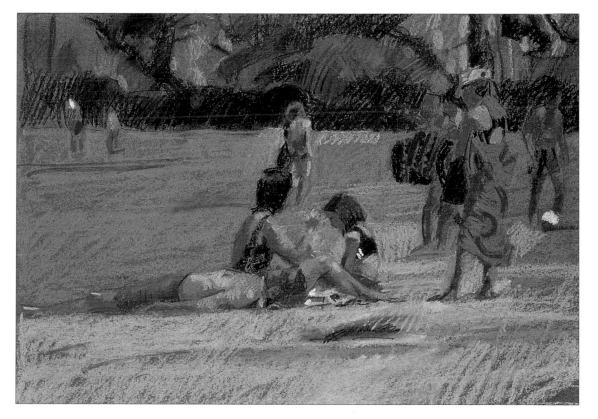

Reworking

T HE EARLIER YOU realize that fundamental changes are needed in a painting, the more easily they can be made. Some media are unforgiving – watercolour and pen and ink are particular examples. Total immersion in water and sponging off is an accepted method for the former, otherwise you may have to either start again or cut out and patch. There are two ways of cutting and patching. For the first, stick a patch which has been feather-edged by tearing over the offending area, and repaint it. For the second, better method, choose your cut to follow existing lines in your painting, and lay a new piece of identical paper under the offending area.

Using a sharp blade, cut out both the area you wish to remove and an identical piece from the sheet underneath, then fit the new piece precisely into the hole and tape it into place on the back.

Practice Exercise: REWORKING IN PAINT

Using opaque materials, such as acrylic and body colour, it is relatively easy to make quite major structural and colour changes directly onto the painting.

1 *In this study, I felt that the background of a white seat and light and dark foliage was intrusive and took away from the sitter's hair and top. Inset: Eradicating light with dark is easy, even with transparent paint. To block out dark with light paint though, you will need an opaque pigment.*

2 *Intensifying the dark-toned effect served to pull the head and top out into the foreground. The composition is much stronger now and there can be no confusion of the figure with the background. Even in the late stages of a drawing or painting never hesitate to make sweeping changes. Be careful, however, to ensure that the changes are the result of direct observation and be consistent with the lighting conditions.*

Cutting Mounts (Mats)

Making your own mounts (mats) allows you to choose exactly how you wish to present your work, but there are a couple of rules that must be taken on board. First, it is imperative that your measurements are completely accurate – the old adage, 'Measure twice and cut once', is vital here. Make sure that your marking tools are accurate and sharpened – using a blunt pencil can ruin all your measuring.

Second, the standard proportions for mounts are that the base area is the largest, the sides next, and the top smallest – there may be exceptions, but these are regarded as the most visually pleasing.

Practice Exercise: BEVEL-EDGED MOUNTS

Whatever the bevel cutter you choose, make sure that it is well made and will cut accurately.

1 On the reverse side, write any measurements and notes, then use a ruler and the back of a straightedge to measure and mark the first line overlength. Position a set square to a ruler on the line, and mark the first right angle.

2 Measure and mark the other lines and right angles. Place a soft board beneath the mount (mat) and line up a straightedge with the first line. Use a bevel cutter to cut to inside the ends of the line. Not all bevel cutters work in the same way, so take time to find out how to use yours properly.

3 Continue cutting the other lines as above. For a double mount (mat), measure and mark the board up proportionally and cut as before. Inset: Make sure that you cut the corners as near as possible to the required size; use spare mount (mat) board for practice.

Glossary

Alla prima
Literally 'at the first' in Italian, this is when a painting is finished in one sitting.

Aquarelle
(1) French for 'watercolour;. (2) a name for water-soluble coloured pencils, where marks and lines can be softened, spread and blended with water.

Blending
Making a smooth meeting point or line where two colours meet, rather than a hard edge.

Body colour
Any opaque pigment; often refers to opaque water-based paints.

Cockling
This wrinkling effect takes place when paint, often watercolour or gouache, is applied to paper that has not been stretched adequately beforehand.

Complementary colours
The colours opposite each other on the colour wheel. The simplest pairs comprise one primary colour and one secondary colour made from the other two primaries; red's complementary, for example, is green (a secondary colour made from blue and yellow).

Conté
Pastel drawing sticks and pencils, slightly harder and more compacted than soft pastels.

Contrast
The juxtaposition of different forms and colours for effect.

Contre-jour
Literally 'against the daylight' in French, this is a painting or drawing in which the light source is behind the subject.

Crosshatching
This technique uses closely drawn or painted parallel lines, crisscrossing each other at any angle, to depict light, shade and tone. *See* Hatching.

Earth colours
Pigments obtained from the ground – the range of umbers, ochres and siennas.

Fixative
A solution sprayed onto a soft drawing medium – charcoal, pastel, conté – to prevent it from smudging or falling off the surface.

Form
The shape, construction and configuration of a body or other object.

Format
The size and relative proportions of the support of a painting or drawing.

Fugitive colours
Colours that fade when exposed to light.

Glaze
Transparent or semi-transparent colours that are laid over each other in layers.

Gouache
See Body colour.

Grain
Also known as tooth, this is the texture of a drawing or painting surface, from fine to coarse.

Ground
A surface prepared to be painted on.

Harmony
(1) The combination of separate parts of a painting and drawing to make a consistent, pleasing whole; (2) groups of colours of a similar wavelength, close together in the colour spectrum or circle.

Hatching
This technique uses closely drawn or painted

parallel lines to depict light, shade and tone. *See* Crosshatching.

Hue
A pure, unadulterated colour from the spectrum.

Impasto
(1) A method of applying paint thickly onto a surface especially to catch light; (2) the finished product using this method.

Key
The overall tone of a painting or drawing – a dark work has a low key, a light work a high one.

Landscape
A term for a format where the painting or drawing is wider than it is tall.

Medium
(1) Anything used as a material by an artist, from a burnt stick to oil paint (the plural here is media); (2) a liquid, such as linseed oil, water or resin, in which pigment is suspended to make paint (the plural here is mediums), also used for dilution of paint while working.

Monochrome
A painting or drawing done in different shades of one colour; also black and white.

Opacity
The quality of a pigment that does not allow light to pass through; the opposite of transparency.

Optical mixing
This term is used to describe colours that are applied direct to a support and mixed by techniques such as hatching and scumbling, not mixed on a palette.

Palette
(1) A holder or surface on which paints are placed for use and mixed; (2) the choice of colours used by an artist in a drawing or painting.

Portrait
(1) A representation of a person or animal, especially of the head and shoulders; (2) a format in which the painting or drawing is taller than it is wide.

Primary colours
On the paint colour wheel, red, blue and yellow.

Scumbling
The method of pulling a layer of opaque, dryish paint over another layer in a different colour so that the bottom layer shows through partially.

Secondary colours
On the paint colour wheel, colours made up by combining equally two primary colours: orange, green and violet. *See* Complementary colours.

Shade
A colour that is darkened with black.

Study
A drawing or painting of part or parts of a composition, but not the whole picture.

Support
The surface on which a drawing or painting is made.

Tertiary colours
On the paint colour wheel, colours made up by combining a primary and a secondary colour: red-orange, yellow-green.

Tint
A colour that is lightened with white.

Tone
Also called value, this refers to the relative lightness and darkness of a colour.

Tooth
See Grain.

Transparency
The quality of a pigment that allows light to pass through it; the opposite of opacity.

Wash
A thin layer of diluted transparent paint or ink, usually broadly applied.

Index

Acknowledgements

The Author would like to extend his thanks to all the models: Shah Amour, Ned
Bent, Karen Braund, Noriko Hasuno, Christopher Gray, Nadia Kebble, Suzie
Withington, Ashley Holt, Daniel Gardner, Robert Gardner, Tasneem Hussain, Riva
Gangin, Sarah Hickey, Simeen Karim, David Westby, Dan Bristow, Alex Glanville,
Holly Guest, Karen Sillance, Elizabeth Tetley, Viv Robertson, Jack Haynes,
Julian Ayres, Nikki Donovan, Sheila Raynes, Gaby Raynes, Jody Raynes,
Lauren Raynes Brooks.

The folk band 'The Sex Slaves from Hell': Richard Harding, Helen Davies,
Lorraine Harris and Gary Tudball.

The Publishers would like to extend their grateful thanks to Ian Kearey, Dawn
Butcher and Janet Swarbrick for their invaluable help. Also, many thanks to
George Taylor and Sarah Hickey for the enjoyable photographic sessions.

The following portraits were reproduced with kind permission:
p. 36: Alec Guiness, permission of Reader's Digest Association
p. 67 and p. 69: winemakers, from the wine list of Robin Yapp.
p. 99: Composite portrait of Patrick Southwell, lent by Richard and Alison Southwell.
p. 101: M. Charvet, Au Comte de Gascogne, Paris
p. 102: Annie Guest
p. 112: Liz Fenwick
p. 113: Anthony Andrews
p. 114: Jenny Agutter

The following illustrations were photographed by Sampson Lloyd:
pp. 18–19, pp. 30–31, pp. 62–65, p. 101 (below right).
All other illustrations were photographed by George Taylor.

128